NORTHWICH & AROUND IN
50
BUILDINGS

ADRIAN AND DAWN L. BRIDGE

AMBERLEY

First published 2021

Amberley Publishing, The Hill, Stroud
Gloucestershire GL5 4EP

www.amberley-books.com

British Library Cataloguing in Publication Data.
A catalogue record for this book is available from the British Library.

ISBN 978 1 4456 9613 3 (print)
ISBN 978 1 4456 9614 0 (ebook)

Typesetting by Aura Technology and Software Services, India.
Printed in Great Britain.

Contents

Map 4

Key 6

Introduction 7

The 50 Buildings 9

Bibliography 94

Acknowledgements 95

About the Authors 96

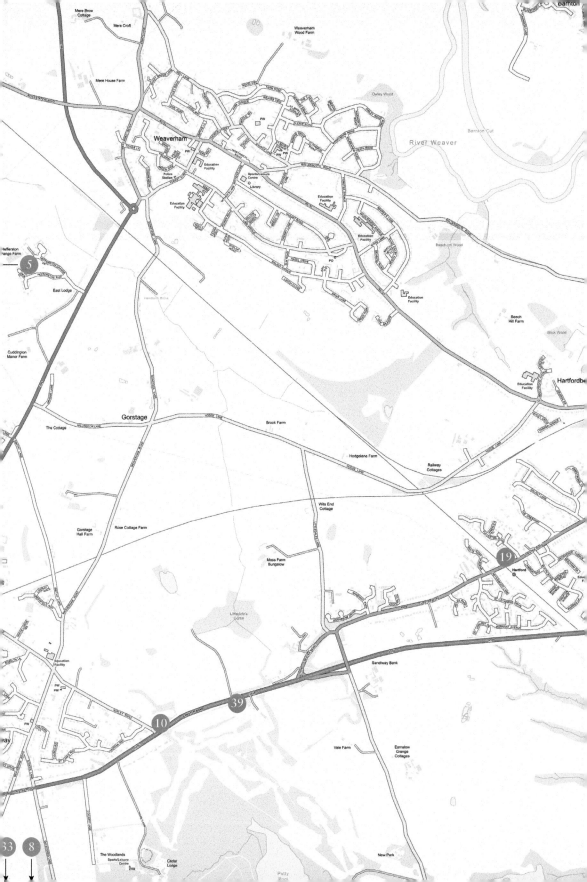

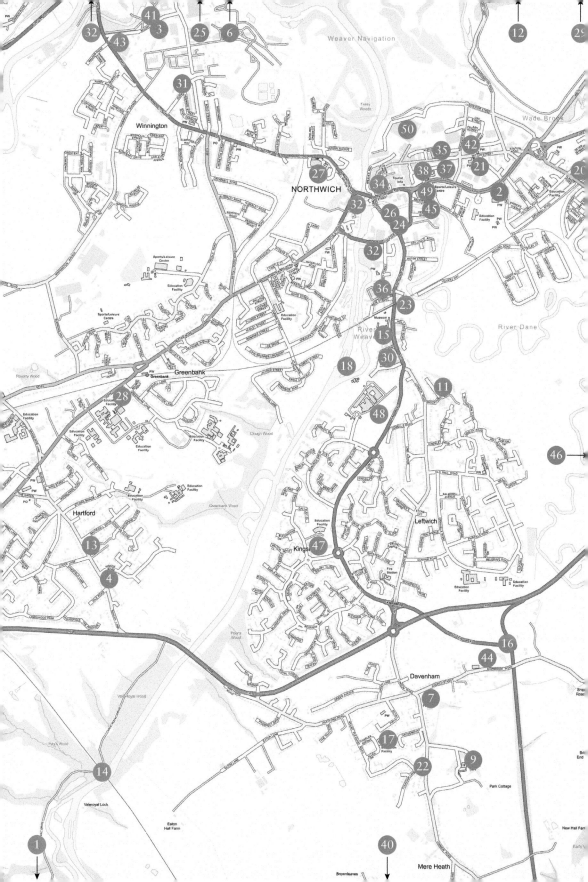

Key

1. Vale Royal Abbey
2. St Helen's Church
3. Winnington Hall
4. Hartford Hall
5. Hefferston Grange
6. Belmont Hall
7. The Bull's Head Inn
8. The Blue Cap Monument
9. Davenham Hall
10. Sandiway Round Tower Lodge
11. The Brockhurst
12. Arley Hall
13. Hartford Lodge
14. Vale Royal Railway Viaduct & Cattle Tunnel
15. Northwich Workhouse
16. St Wilfrid's Church, Davenham
17. Davenham Victorian Primary School
18. Hunt's Locks
19. Mersey Vale
20. Northwich Railway Station
21. St Wilfrid's RC Church, Witton
22. The Hosken-Harper Memorial
23. Northwich Railway Viaduct
24. The Bridge Inn
25. Anderton Boat Lift
26. Parr's Bank Building
27. Victoria Infirmary
28. The Greenbank Hotel
29. Lion Salt Works
30. Verdin Technical Schools
31. Winnington Park Recreation Club
32. Swing Bridges of Northwich
33. Nunsmere Hall
34. The Salty Dog
35. Northwich Public Library
36. Dock Road Pumping Station
37. The Penny Black
38. RAOB Building
39. Sandiway Golf Club & Clubhouse
40. Regent Street & Moulton War Memorial
41. I.C.I. & Alkali Division War Memorial, Winnington Works
42. Plaza Cinema
43. Winnington Research Laboratories
44. Davenham Players Theatre
45. Northwich 'Old' Fire Station
46. Roberts' Bakery
47. Kingsmead Primary School
48. Sir John Deane's College
49. Northwich Memorial Court
50. Barons Quay

Introduction

The town of Northwich has a rich and varied history stretching back nearly 2,000 years to a time when the Romans established a small auxiliary fort and settlement at Condate (in the Castle area of modern Northwich) during the first century CE. For most of the subsequent 2,000 years Northwich remained an extremely small settlement, focused almost entirely on the economic activity of salt production. During the pre-industrial age, for example, it's likely that the 'town' of Northwich consisted of little more than 6 acres of open salt pans and scattered 'wych' houses, where salt was produced. This small enclave was centred upon the area now occupied by the modern Bull Ring, and surrounded by much larger townships such as Leftwich, Witton and Rudheath. From the mid-nineteenth century onwards, Northwich became something of a boom town, aided by the continued expansion of the salt industry, and by the fact that the town became the centre of an internationally recognised soda ash and chemical industry. As a result, the town expanded to incorporate many of its neighbouring parishes and townships. Indeed, modern Northwich now stretches a good few miles out into the mid-Cheshire countryside, and a continuous ribbon of development connects the town of Northwich with all these outlying parishes and townships.

During the course of this book, a selection of fifty buildings and structures will be examined which encompass both the 'old' and miniscule central part of Northwich, and the wider areas around it. Not surprisingly, perhaps, many of the buildings selected for this book will reflect the strong industrial heritage of Northwich and its surrounding areas. Salt was the predominant industry in the town for centuries, and its impact upon the architectural landscape of the area was immense. Salt magnates like the Verdin brothers ploughed much of their fortunes into the creation of public buildings like the Verdin Technical Schools, on London Road, and the Victoria Infirmary on Winnington Hill. On the negative side, many of the town's key buildings collapsed as a result of the subsidence caused by unregulated brine pumping and years of rock salt mining. The difficult geological and structural conditions in Northwich led to the development of a particular type of building closely associated with the town – lightweight, portable structures which could be lifted up and moved in order to avoid collapsing into the massive subterranean voids caused by centuries of salt extraction. These portable, black and white buildings, created in the late nineteenth and early twentieth centuries, are now iconic architectural features of Northwich, and will be covered in some depth during the course of the coming pages.

The soda ash and chemical industry had an equally significant impact upon the buildings of Northwich and its surrounding areas. The Brunner Mond chemical empire created at Winnington in the 1870s – which later developed into Imperial Chemical Industries (I.C.I.) in the 1920s – transformed Northwich into a chemical town. Sir John Brunner, the founding father of the town's soda ash industry (along with Ludwig Mond), invested considerable sums of money in a range of public building projects in Northwich and elsewhere, much of which are still visible today. The profits of the slave trade also had quite a significant, if lesser-known, impact on the architectural landscape of Northwich and its surrounding areas. Davenham Hall and Winnington Hall were both constructed, in part, with money derived from slave and plantation interests, and government compensation provided for the 'loss' of slaves (predominantly in the 1830s) helped provide a number of prominent local gentry and business figures with enough spare money to invest in various local building schemes.

The buildings chosen for this book will, however, shed light on far more than just the industrial and commercial heritage of the Northwich area: structures of all types will be assessed, including the grand country houses of the local gentry, war memorials, public houses, churches, hotels, a former cinema, and a rather unique monument to a speedy Hanoverian dog called Blue Cap. The reader will be taken on a historical tour of local buildings spanning over 700 years, from the construction of Vale Royal Abbey in 1277, right up to the completion of Barons Quay in 2017. The area has a great many structures listed as being of either Grade I, Grade II or Grade II* status in the government's *Statutory List of Buildings of Special Architectural or Historical Interest* (local councils have ultimate responsibility for ensuring the preservation of such buildings). Grade I buildings are deemed to be of international importance, whilst Grade II and Grade II* structures are of at least some national importance. 'Northwich & Around' has buildings in all these categories, and we hope that the reader enjoys finding out more about the rich mix of buildings and structures, listed and unlisted, which make up the fascinating architectural landscape of this area.

The 50 Buildings

1. Vale Royal Abbey

One of England's greatest and most powerful medieval monarchs, Edward I, laid the foundation stone for the new Cistercian abbey of St Mary's, at Whitegate, just outside modern Northwich, in 1277. Edward called the site for the new abbey Vallis Regalis, or Vale Royal. The white-robed monks of the Cistercian order moved into the premises in 1330, although the new abbey wasn't actually completed until 1359. Vale Royal Abbey was certainly a massive undertaking, and at 421 feet in length, it was actually longer than Westminster Abbey in London. Vale Royal monks continued to follow the rules and precepts of St Benedict until they were dissolved by Henry VIII in 1542. Subsequently, Sir Thomas Holcroft bought the abbey and its estate for £450. He then proceeded to dismantle much of the abbey, and he used many of its fixtures and fittings to build himself a new manor house nearby.

Exterior front view of Vale Royal Abbey.

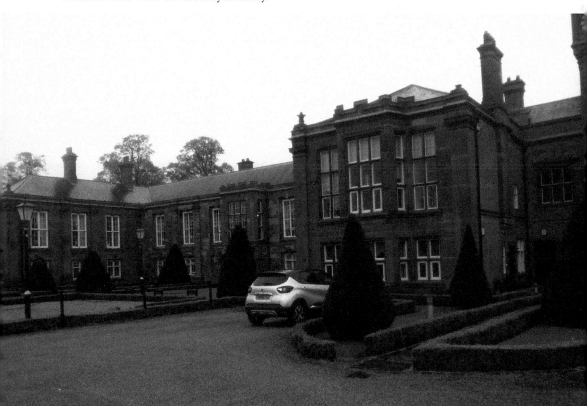

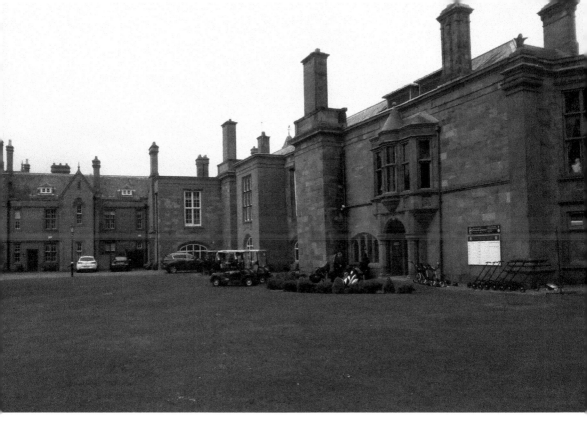

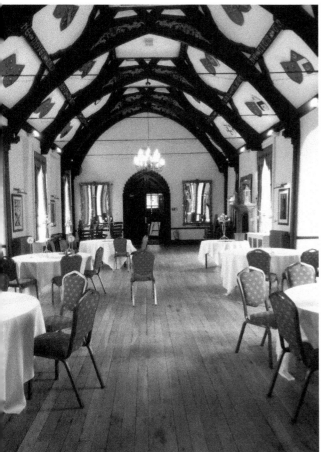

Above: Exterior rear view of Vale Royal Abbey.

Left: The ornate Abbey saloon room.

The Holcroft family later made a considerable profit from their purchase when they sold the Vale Royal Abbey and estate to Lady Mary Cholmondeley, for the considerable sum of £9,000, in 1616. The Cholmondeley family were to retain Vale Royal Abbey as their family seat for the next eight generations, and only sold off their final rights to the associated property and lands in 1939. The eldest Cholmondeley males became Barons of Delamere from 1821 onwards, though by the early twentieth century, the Delameres were mostly focused on developing their vast farming estates in Kenya.

Vale Royal Abbey was rented out to the wealthy Dempster family from 1907 until 1925, and the American Rimmers leased the property in the 1930s. Between 1940 and 1948, the abbey became a sanatorium, and between 1948 and 1960, I.C.I. made use of the property. After this, the eighty-six-roomed former abbey was used for a variety of purposes, though it remained unoccupied and neglected for most of the 1980s. However, in the late 1990s, Vale Royal Abbey began its transformation into a rather exclusive golf club (with some private apartments attached) and the abbey, and its landscaped gardens, has also become a popular wedding venue.

2. St Helen's Church

St Helen's Church, at the top of Chester Way, is by far and away the oldest building in central Northwich, with a history that stretches back to the fourteenth century. The church is a Grade I listed building, often referred to as the 'Cathedral of Mid-Cheshire', and frequently described as being one of England's finest parish churches. Of course, for most of its history, St Helen's Church has been a chapel of ease rather than a parish church.

Chapels of ease were really a subsidiary category of church, providing a place of worship for parishioners unable to get to their main parish church. Until it became a parish church in its own right, in August 1900, St Helen's was the chapel of ease attached to the parish church of St Mary and All Saints, in Great Budworth. A chapel of ease has been present on the site of St Helen's since the fourteenth century. This chapel was roughly the same size as the modern St Helen's Church, but it would have had no aisles, and the only seating available was on stone benches situated around the walls.

Although some of the fourteenth-century parts of the church are still in view, the church as it currently stands was created mainly through two subsequent phases of construction. During the Tudor period, an impressive roof was constructed (the roof over the nave was probably completed by 1550). After this, the church was heavily restored during the nineteenth century, with three spectacular, large, coloured stained-glass windows being installed behind the altar in 1861–62. By the 1890s, most of the key improvements and renovations had already been completed, and the architecturally striking church that emerged was very much the church that we see today.

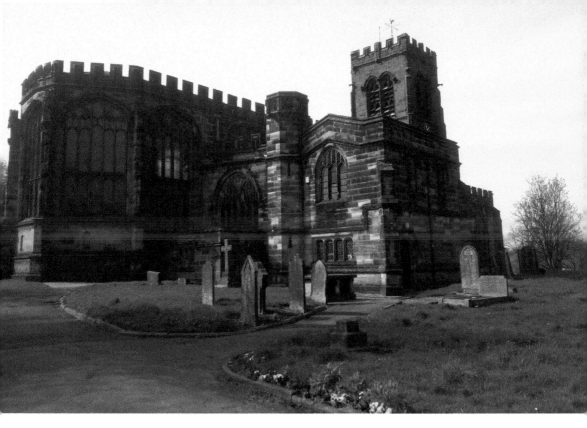

Above: Exterior view of St Helen's Church.

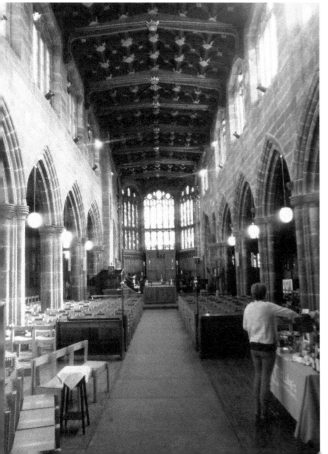

Left: Interior aisle view leading to the altar.

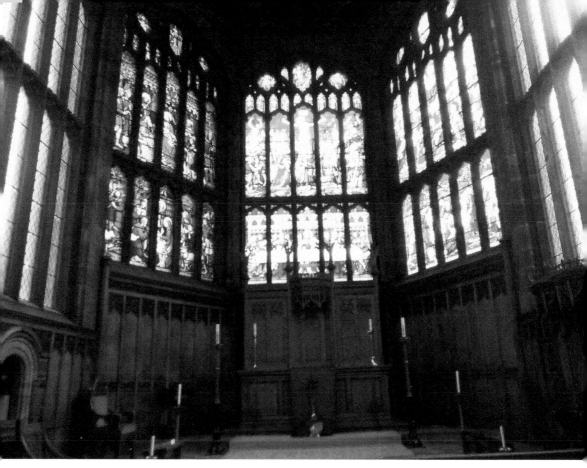

Victorian stained-glass windows, installed in 1861–62.

3. Winnington Hall

Winnington Hall is undoubtedly one of Northwich's great architectural treasures. The Grade I listed building is really three buildings in one, with a Tudor timber wing, a Georgian stone wing, and a brick service wing, where servants and household staff lived. The oldest part of the Tudor wing is undoubtedly the gable end, which probably dates back to the mid-sixteenth century. The Georgian wing, built between 1773–75, was probably designed by the architects Samuel and James Wyatt. This part of the hall has some magnificent surviving features, such as the Octagon Room and the Orangery, where orange trees were grown in tubs on stone floors. These trees were wheeled outside during good weather, but kept inside in the Orangery during periods when Northwich's weather was particularly inclement.

Over the centuries, a number of great local gentry families have lived at the hall, including the Warburtons, the Penrhyns, and the Stanleys. Richard Pennant, 1st baron of Penrhyn, who built the hall's extension, died in debt in 1808, despite having considerable slave-owning interests in Jamaica, and a slate quarry in Wales. The Stanleys of Alderley were largely absentee landlords during their time at

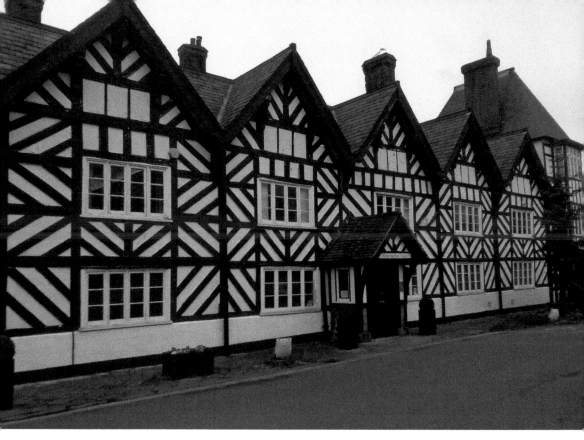

Above: Tudor wing of Winnington Hall.

Below: Entrance to the Tudor wing.

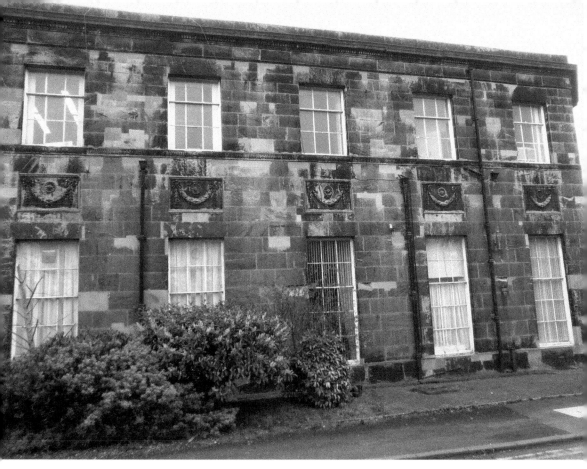

Georgian stone wing of the hall.

the hall. Various Stanley tenants occupied the hall during the mid-nineteenth century, including the impecunious Bell sisters, who ran a small girls' school at the premises, which was heavily subsidised by the artist John Ruskin.

John Brunner and Ludwig Mond were the most notable occupants of Winnington Hall, from 1872 onwards. The Brunner family lived in the Tudor wing, while the Mond family stayed in the stone wing. Once the Brunner Mond empire had risen to dominate the soda ash industry, both men soon moved out. Mond left for palatial quarters near Regent's Park during the 1880s, and once Brunner had become Northwich's MP in 1885, he spent more and more time in London. Winnington Hall increasingly became the preserve of the two men's children, and of Brunner Mond's key directors and managers.

In 1897, the Winnington Club was formed, which was a very early example of a company social club, designed to provide opportunities for social interaction between staff members and families. This club survived, in various guises, for over a hundred years, and continued even after I.C.I. severed all links with Winnington Hall in 1995. Currently, the splendours of Winnington Hall are utilised by a whole range of independent businesses and organisations, whose staff work in what must surely be Northwich's most opulent and distinctive office accommodation.

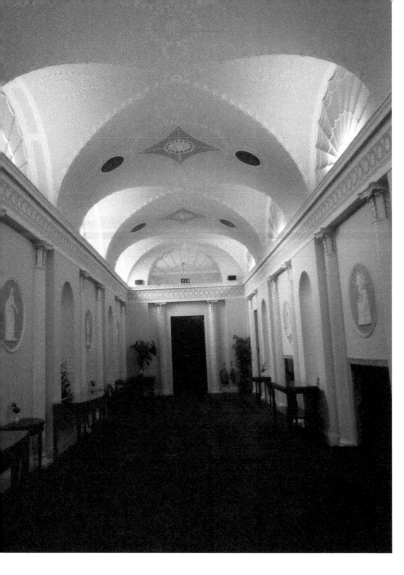

The Long Gallery,
former home of
Ludwig Mond's
art collection.

4. Hartford Hall

The history of Hartford Hall, on School Lane, Hartford, certainly goes back quite
a long way. Currently, it's part of a hotel and restaurant chain, but in bygone times,
Hartford Hall was a manor house and also a private residence for some notable
Victorian families. A nunnery, or at least a property linked to nearby Vale Royal
Abbey and the nuns of St Mary's Chester, may well have existed on exactly the
same spot in pre-Reformation times. These rather general and tenuous historical
factors have helped give rise to the myths and legends about the ghost of a nun
appearing to staff and visitors at Hartford Hall. These legends have obviously
been good for business, and helped attract a ghost-hunting hotel clientele, but
even without the ghostly nun story, the documented history of Hartford Hall
remains an interesting one.

Elements of the old Tudor/early Jacobean manor house still survive to this day. The entrance porch is original, and Jacobean plaster panels adorn the ceiling. Also, upstairs in the so-called Nun's Room, exposed structural purlin roof beams can still be observed.

By the mid-1800s, Hartford Hall formed part of the property empire of Thomas Firth, a prominent local businessman who owned his own bank in Northwich. Firth lived at Hartford Lodge, further along School Lane, and during the 1840s, Hartford Hall was occupied by tenants such as the Revd Arrowsmith. When Firth died in 1861, the hall was sold off as part of a great sale organised by Churton & Co., which took place at the Crown & Anchor Hotel in Northwich. At the time of the sale, the Hartford Hall estate included numerous outbuildings and 2 acres of pleasure gardens. Despite the sale, however, the link between the Firths and Hartford Hall was destined to continue. Thomas Firth's only daughter, Emily, married George Hatt-Cook, a prominent consultant surgeon, and Hartford Hall became the home of the expanding Hatt-Cook family until at least the time of the First World War. Indeed, during the Great War, the Hatt-Cook's used Hartford Hall as a voluntary hospital working party base, where bandages, splints and other medical aids were produced and then sent to the nearby hospital working depot at Hartford Lodge.

By the end of the Great War, the Hatt-Cook's family connections spread far beyond Hartford Hall and Hartford Lodge, and incorporated the Cheshire family of Chester, amongst others. Emily Firth's great-grandson was none other than the legendary Leonard Cheshire VC, Second World War Bomber Command hero, and founder of the Cheshire Homes.

Hartford Hall, as seen from School Lane, Hartford.

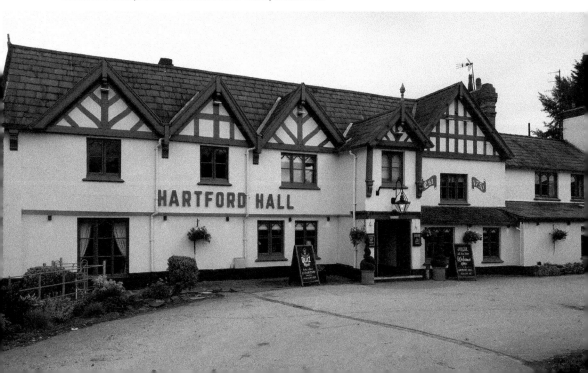

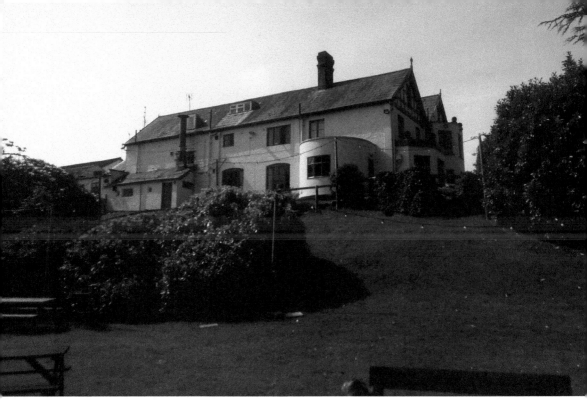

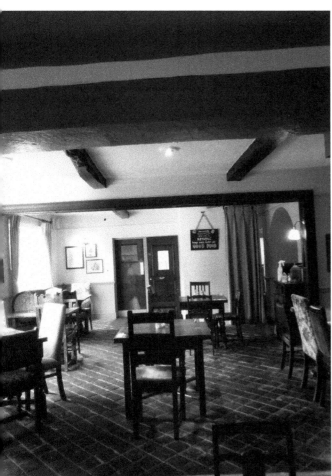

Above: Rear view of the hall, as seen from its former 'pleasure grounds'.

Left: Beamed ceiling in the dining room.

5. Hefferston Grange

A building has stood on the site of Hefferston Grange, just to the southwest of Weaverham village, since at least 1700. However, the more modern grange that we see today was constructed, to an early Georgian design, in 1741. Later neoclassical additions were made to the Grade II* listed building during the 1770s, and further Victorian extensions (including a wrought-iron conservatory) were completed during the 1800s. Just outside the building, a few metres to the west, lie the remains of a 200-year-old icebox, covered in earth, and missing most of its entrance way. Here, in the pre-refrigeration age, this architectural curiosity was used by the grange's various occupants to preserve food and other items for the maximum possible period.

Philip Henry Warburton was the first significant owner of Hefferston Grange, and he lived at the property until his death in 1760. Warburton was a lawyer, magistrate, and an MP for Chester during the 1740s. He had a peripheral involvement in the events of Bonnie Prince Charlie's 1745 Jacobite rebellion, when (as a magistrate) he interrogated one of the Young Pretender's messengers to the Jacobite sympathiser, Lord Barrymore.

Nicholas Ashton, High Sheriff of Lancashire, lived at the Grange during the 1770s, when he used his considerable wealth to add neoclassical flourishes to the Weaverham property. Ashton, however, had more important interests in Liverpool, and it wasn't until the latter part of the nineteenth century that Hefferston Grange had its last great independent owner, who was focused solely on developing the property and its lands. Robert Heath, and his family,

Front entrance to Hefferston Grange.

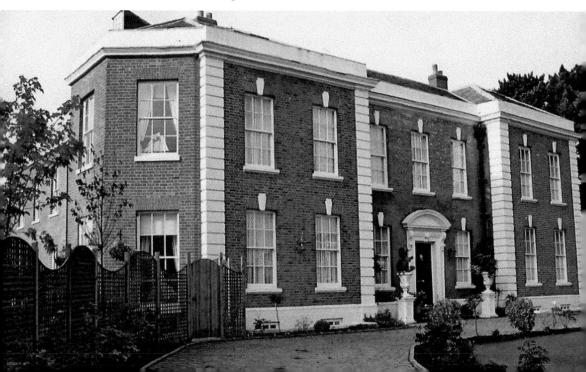

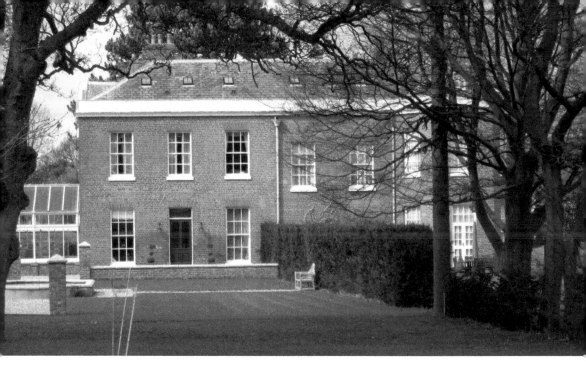

Hefferston Grange, as seen from the south. (Courtesy of Dr Duncan Pepper)

occupied Hefferston Grange and its surrounding lands for roughly forty years, between the 1860s and the early 1900s. In the 1841 census, Heath – a Londoner from Stepney – was described as being of 'null' occupation. By 1881, however, he had found his true vocation in life as a farmer and landowner. He farmed 260 acres of land in Weaverham, employed ten labourers, and utilised six servants in the grange building itself.

Heath's 1876 extensions to the property were the last great alterations to Hefferston Grange before it became a sanatorium in 1921. In that year, Warrington County Borough purchased the property and transformed it into Hefferston Grange Sanatorium (a hospital used for the treatment of tuberculosis cases). The grange continued as a sanatorium until 1948, when the property was converted into the more general Grange Hospital, Weaverham, and later became part of the National Health Service (NHS). Eventually, in 1986, the property was sold off by the NHS, and Hefferston Grange reverted to private ownership. New housing arose on its lands, and the grange itself was divided into various offices and apartments.

6. Belmont Hall

The magnificent Grade I listed Belmont Hall is situated a mile or so outside the picturesque village of Great Budworth. The house was commissioned by the wealthy John Smith-Barry in 1749, and the man given the job of designing Smith-Barry's new home was the nationally known Scottish architect James Gibbs,

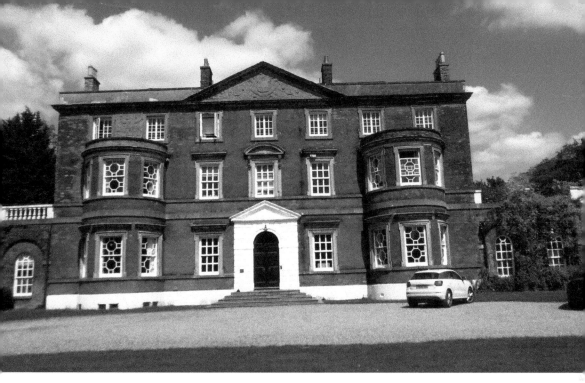

Exterior frontage of Belmont Hall.

who was also responsible for creating Cambridge University's new Senate House, the Oxford Camerata building, and St Martin's-in-the Field Church in Westminster. Gibbs envisaged a hall with six ground-floor rooms, though a seventh room was added in the nineteenth century. The architect was influenced strongly by the work of Andrea Palladio, and Belmont Hall might have had a stronger Palladian influence had Gibbs not died a year before the completion of the hall, in 1755.

Following Gibbs' death, it is believed that some of the plans for the hall's design were revised and changed by one or more local architects. Nevertheless, the home that Smith-Barry moved into in 1755 was still one of the grandest in the county. When he died in 1784, his art collector son, James Hugh Smith-Barry, inherited the property. Henry Clarke bought the hall in 1801, following the death of James, and he in turn sold the property to the Leigh family, who still own Belmont Hall today. Since then, the house has had some varied tenants: between 1918 and 1926, for example, Belmont Hall was occupied by Roscoe Brunner, chairman of Brunner Mond, and his wife, Ethel.

Roscoe and his closest Brunner Mond colleagues completed many of their key business transactions at the hall. At the same time, Ethel Brunner made Belmont the centre of some glittering social and political events, hosting at least one Conservative Association gathering attended by over a thousand people. In more recent times, Belmont Hall has been the home of Cransley School, a successful co-educational private school, begun in 1977. Parts of the hall's land are also occupied by a caravan and camping site.

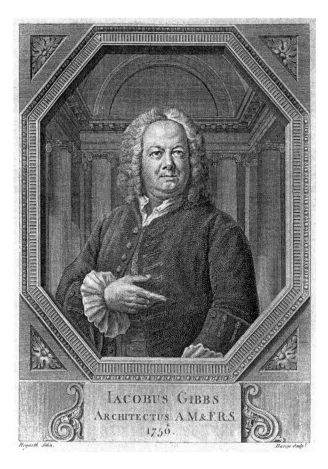

Portrait of James Gibbs, 1750. (© Wellcome Library, London)

The architectural treasure trove that Belmont Hall represents is perhaps best emphasised by the fact that even the two lodges at the entrance to the estate are Grade II listed properties. In addition, its fishpond and moat site are also recognised as being nationally important Scheduled Monuments.

7. The Bull's Head Inn, Davenham

The Bull's Head is an excellent example of a Georgian country inn, with a documented history stretching back to at least the mid-eighteenth century. During its Georgian heyday as a coaching inn, the Bull's Head was certainly a hive of activity, with passengers alighting and departing, via horse-drawn coach, for London, Warrington and other destinations. In addition, horses were moving in and out of the Bull's Head's quite extensive stabling facilities, and the inn was producing its own beer in malt kiln annexes. Large stone mounting blocks were also put outside the front of the Inn, to enable ladies to mount their horses decorously, in side saddle fashion – one block still remains, in situ, outside the

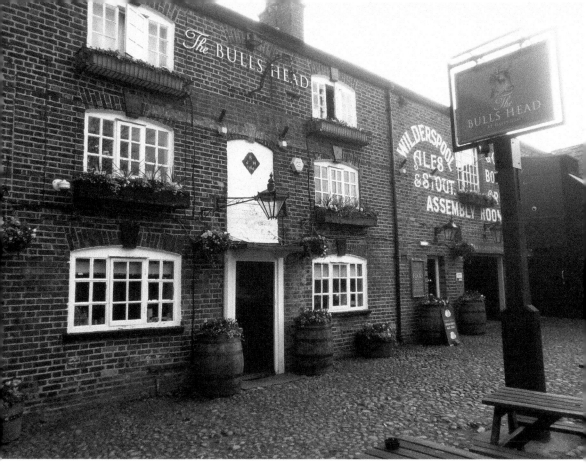

The Bull's Head Inn, Davenham.

former stables. The Bull's Head also possesses a small but classic period assembly room where people could meet, pay their bills, and dance the night away. Functions at country assembly rooms traditionally took place once a month, and evening functions were often timed to coincide with a full moon, when it was safer and easier for people to travel.

The licensee of the Bull's Head in the mid-1700s was John Royle, who oversaw the inn's various activities until 1783, when his son-in-law, Abel Trim, took over as the licensee. The Trim family later went on to become considerable property owners in Davenham, acquiring at least fifteen cottages and houses across the village. By the end of the nineteenth century, the importance of both assembly rooms, and the coaching trade, for inns such as the Bull's Head, had been in decline for some time. Nevertheless, the Bull's Head was still a popular meeting place. In the 1930s, for example, the members of the Cheshire Hunt often gathered outside the front of the Bull's Head (superintended by the master of the hunt, Peter Russell-Allen, owner of nearby Davenham Hall) before charging off over the fields to Bostock. Cyclists and ramblers have now largely replaced the fox-hunting fraternity, but the Bull's Head remains a popular local attraction.

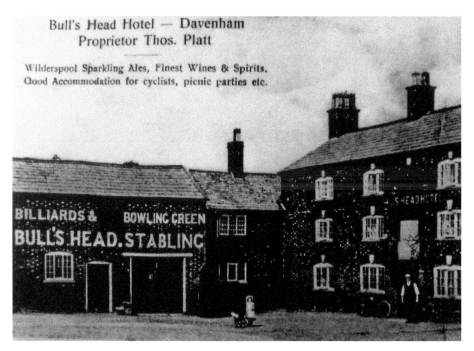

Bull's Head Inn *c.* 1911, when managed by Thomas Platt from Earlestown.

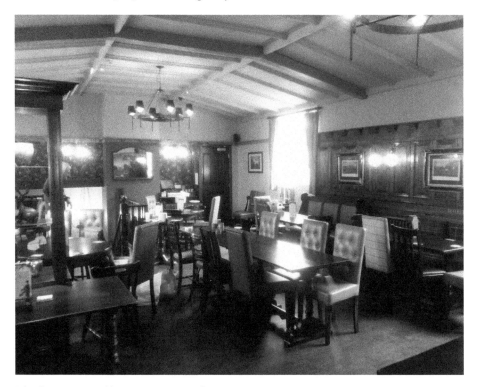

The former assembly room – now a dining area.

8. The Blue Cap Monument

The Blue Cap monument in Cuddington has the unusual distinction of being a structure which commemorates canine rather than human endeavour and achievement. Blue Cap was a foxhound born in 1759, and owned by John Smith-Barry, of the distinguished local landowning Smith-Barry family. In 1763, Blue Cap was the subject of a huge bet between Smith-Barry and Hugo Meynall, founder of the Quorn Hunt. Both men wagered the substantial sum of £500 on their dogs winning a 4-mile race around the famous Newmarket racecourse in Cambridgeshire. Each owner had two dogs in the race – Blue Cap and Wanton (Blue Cap's daughter) raced Meynall's dog Richmond, and another unnamed bitch. Meynall's hounds were strong favourites to win the race, but against all the odds, Blue Cap won easily, and was followed by Wanton in second place. John Smith-Barry won £400 for Blue Cap's first place, and another £100 for Wanton coming second. When Blue Cap died in 1772, John Smith-Barry paid for the construction of the memorial which can still be seen today. The memorial itself comprises a sandstone obelisk with a rather worn brass plaque attached, inscribed with a poem dedicated to 'a Hound that deserves to be prais'd'.

The Blue Cap Memorial. (Courtesy of Andrew Fulton)

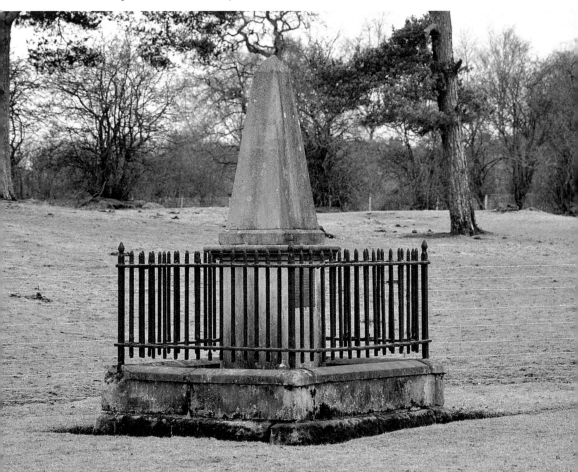

9. Davenham Hall

Davenham Hall, just off London Road, in the village of Davenham, has been the seat of powerful and wealthy local gentry families for many centuries. Four great families have resided at the hall – the Holfords, the Hosken-Harpers, the France-Hayhursts, and then the Allens. The Holfords were linked with Davenham Lodge, the timber construction which preceded Davenham Hall, since the time of the early Tudors (and before). Allen Holford, the last of the lodge-based Holfords, sold the property to his brother-in-law, Thomas Ravenscroft, in 1771. When Ravenscroft died in 1795, Davenham Hall was purchased by William Harper, a major Liverpool-based slave trader with substantial plantation interests in Monserrat. Harper's daughter, Ann, married a Cornishman called John Hosken, who took on the surname Hosken-Harper, and inherited the Davenham Hall estate when William Harper died in 1815.

Davenham Hall, as it stands today, with its elegant Ionic columns, shallow interior dome, and other neoclassical features, was largely the creation of John Hosken-Harper, using the money inherited from his father-in-law's extensive West Indian slave interests.

Davenham Hall.

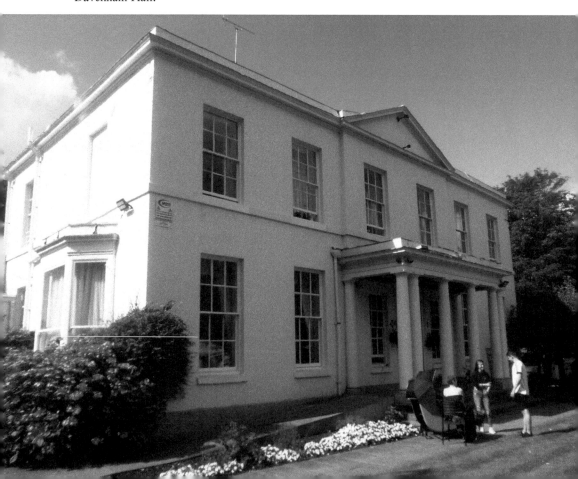

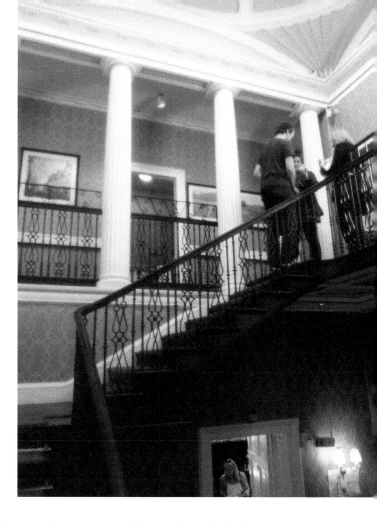

Central stairway leading to
first-floor rooms at the hall.

The France-Hayhursts became the squires of Davenham Hall during the latter part of the nineteenth century, when John and Anne Hosken-Harper's daughter, Helen, married the Revd Thomas France Hayhurst in 1872. By 1909, however, Davenham Hall had passed from the France-Hayhursts into the hands of Russell Allen, owner and proprietor of the *Manchester Evening News* newspaper, and a man of considerable wealth. His three unmarried daughters, Doris, Geraldine and Margaret, remained residents of Davenham Hall for nearly seventy years, and were, in many respects, the most energetic and admirable of all of the hall's many occupants. Doris won the French Croix de Guerre, with Bronze Star, for her service on the Western Front during the First World War. Geraldine obtained a richly deserved OBE for her unstinting work, over forty years, in helping to maintain and expand Chester Zoo. Margaret Allen wrote charming Chihuahua-based fairy stories for children.

As the sisters grew older, and health worries began to predominate, Davenham Hall began to look rather dilapidated. Doris was the last of the sisters to pass away, in 1979. After this, the hall was converted into a nursing home – a function which it still has (under different management) to this day.

Ground-floor bells used to summon servants to particular rooms.

10. Sandiway Round Tower Lodge

Sandiway Lodge, situated on the main Manchester to Chester road, has been a familiar sight for drivers on the A556 for many years. The circular two-storey sandstone structure has an impressive studded oak door and three Gothic-style windows, all topped by a crenelated parapet. It was built for the Cholmondeley Barons of Delamere during the early years of the nineteenth century, and guarded the entranceway to the Vale Royal estate's New Park (now known as Pettypool).

Originally, the building encompassed more than just the circular tower that exists today. There used to be a bedroom and a kitchen extension, which were both demolished when the main road was widened in 1930. The tower has been isolated on the central reservation of what is now the busy A556 road since 1958. In 2013, the structure was largely destroyed as the result of a road traffic collision. Local campaigners and council officials then combined to launch an ambitious reconstruction programme, and during 2015, 450 sandstone blocks, weighing 15 tons, were put in place to create a fully restored Sandiway Round Tower Lodge.

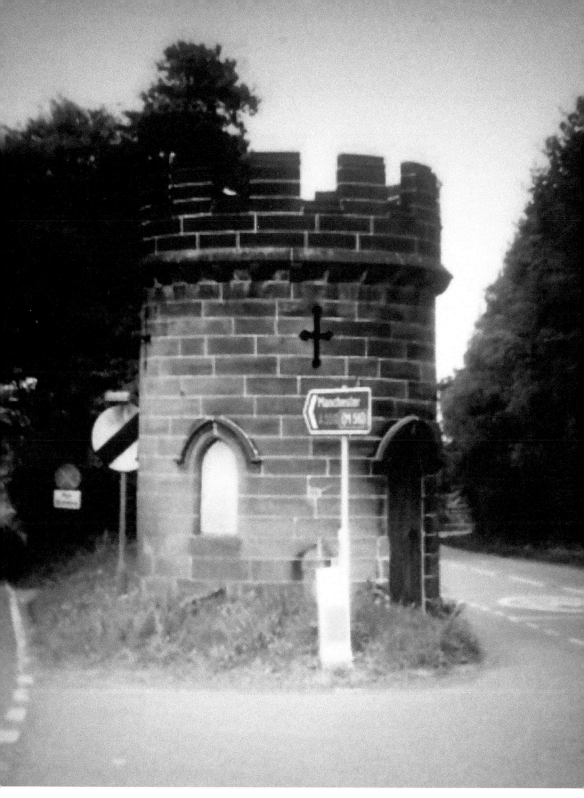

Sandiway Round Tower Lodge in 2006. (Courtesy of Jo Lxix)

11. The Brockhurst

In modern times, the interior of The Brockhurst (or Brockhurst Hall as it was often known) in Leftwich has been converted into a number of quite spacious flats and apartments. The exterior of the Grade II listed building, however, remains much as it was some 200 years ago, when it was first built, with an imposing four-columned Ionic porch, substantial oak panelled doors, and grey slate roofing.

During most of the nineteenth century, The Brockhurst was a house run on the profits generated by Northwich's substantial salt industry. Its first major salt-linked owners were the Worthington family. The head of this early Victorian Brockhurst-based family was William Worthington, who was a substantial local landowner, JP, and a proprietor of salt mines. He lived at The Brockhurst in some style, with his wife Mary, children, and five servants. Like many other local gentlemen, William Worthington worked hard to increase his family alliances in the area. In 1849, his youngest daughter, Mary, left The Brockhurst to begin married life with William Brocklehurst, of Prestbury, who was the son of Macclesfield's MP.

Given William Worthington's strong links to the Northwich salt trade, it's no real surprise that ownership of The Brockhurst passed to Robert Verdin and the Verdin family shortly after Worthington's death in 1875. Robert and Joseph Verdin were really the greatest Victorian salt dynasts of them all. By the end of the 1870s, Robert and his younger brother, Joseph, were controlling a salt empire consisting of over 1,000 employees, and six local salt mines. Both brothers remained unmarried throughout their lives, and lived at The Brockhurst with their

Front view of The Brockhurst.

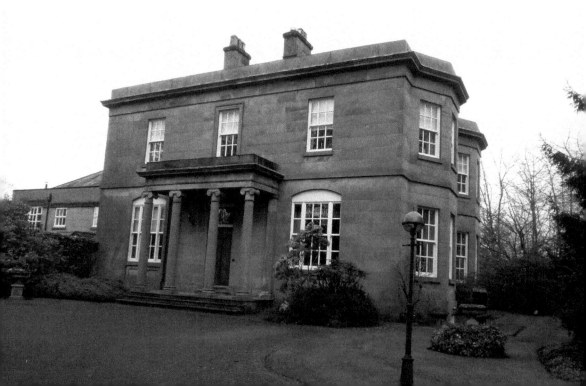

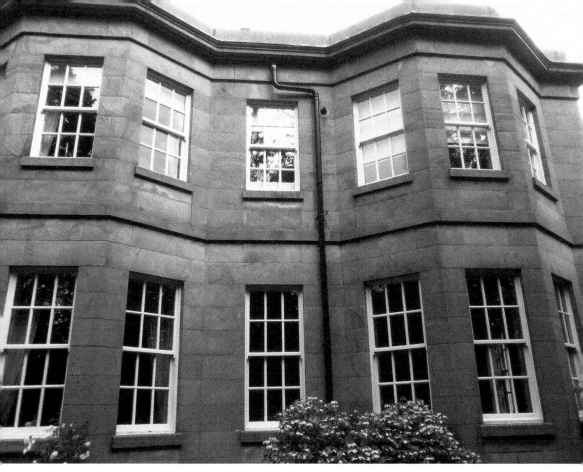

Above: Double-bay window side view of The Brockhurst.

Right: The Brockhurst's entrance hall, with ornately tiled floor.

sister Mary (also unmarried) and between four and six household servants, who were accommodated in various parts of the main house, and its annexes.

Robert Verdin's burgeoning political career as Northwich's MP was cut short by his premature death in 1887. After this, Joseph and his sister Mary continued to live at The Brockhurst until both relocated to Garnstone Castle, in Herefordshire, in 1900.

12. Arley Hall

There has been a house on the site of Arley Hall, a few miles to the north of Northwich, since at least the twelfth century. However, the building as it is today was constructed largely between 1832 and 1845 by Nantwich-based architect George Latham. Latham was a young man in his twenties at the time he received the commission to build a new Arley Hall, from Rowland Egerton-Warburton, the equally young new owner of the Arley estate, born in 1805. Both architect and owner engaged in an interesting partnership, visiting other buildings together, and seeking inspiration from the Elizabethan and Jacobean architectural styles they encountered.

The new Arley Hall that arose after 1845 certainly reflected the Tudor and Stuart design points both men admired, and resulted in a building sometimes

Arley Hall. (Courtesy of Peter I. Vardy)

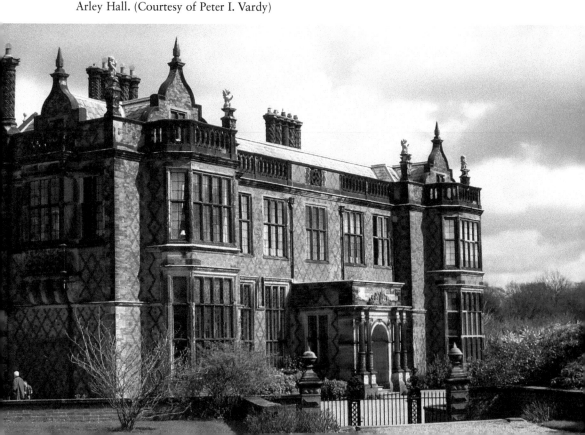

described as being 'Jacobethan' in style. The new building was also more expensive than planned, costing over £30,000 rather than the £6,000 originally predicted by Latham. Nevertheless, over time, the splendid stately home has certainly provided value for money. The house and gardens have been a popular tourist attraction since the 1960s, and numerous fairs, concerts and other major events now take place at the venue.

13. Hartford Lodge

The late Georgian neoclassical Hartford Lodge (now called Whitehall) on School Lane, Hartford, was built in 1835 by John Douglas Senior, father of the more prolific architect John Douglas Junior, who designed hundreds of buildings throughout Cheshire and beyond, between 1860 and 1909. Douglas's Lodge was certainly an opulent, elegant place to live, with an Ionic porch at its entrance, umpteen rooms and outbuildings, and acres of south-facing lawns and gardens.

 Thomas Firth and family were the first significant occupants of the lodge. Firth was an immensely successful Victorian banker and entrepreneur, with many different business interests. He owned a bank in Northwich, which was purchased by Parr's Bank in 1865. In addition, he had investments in the Winnington Salt Works, the Dunkirk salt mine, and the St Helens coalfields. He also owned considerable property and land elsewhere in Hartford, including nearby

Hartford Lodge, as viewed from its south-facing lawns.

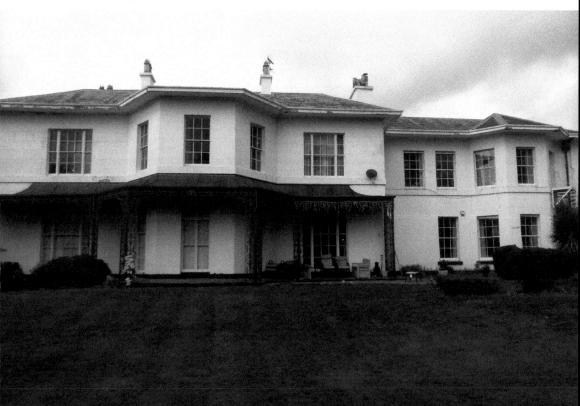

Hartford Hall. When he died in 1861, he left an estate worth at least £30,000 (equivalent to around £3,500,000 in today's money).

The next really notable residents of Hartford Lodge were the Hungarian immigrant Gustav Jarmay and his wife, Charlotte, who was the daughter of a prominent Northamptonshire surgeon. By the time the Jarmays were living at Hartford Lodge in the 1890s, Gustav had risen to become a principal director of Brunner Mond, one of Britain's greatest chemical companies (and later part of the huge I.C.I. conglomerate).

During the First World War, Hartford Lodge was transformed into a centre of wartime activity. Charlotte Jarmay registered the lodge as a hospital work station, where bandages, splints and other first-aid necessities were produced. Hartford Lodge also became a Works Depot – a place where hospital supplies were collected from other work stations in the area, and then distributed to various auxiliary hospitals according to need. Not content with this, Charlotte Jarmay also became the co-commandant of the Ley Auxiliary Hospital in Winnington, Northwich. While Charlotte made Hartford Lodge a central focus of hospital activity, Gustav Jarmay worked hard to expand Brunner Mond's munitions war effort. Both husband and wife proved to be successful in their efforts. Gustav was rewarded with a knighthood by Lloyd George's grateful government, and the new Lady Jarmay was given an OBE for her prodigious hospital and first-aid efforts.

Below left: Central staircase and balustrade.

Below right: Ornate dining room ceiling rose.

After the war, the Jarmays retired to Italy and then Hertfordshire. In more modern times, Hartford Lodge has been used as a council office. Currently, Whitehall is the home of a cardio-vascular medical business. Charlotte Jarmay for one (given her medical connections) would probably have approved of her former home being used as the base for a medical and health-related business.

14. Vale Royal Railway Viaduct and Cattle Tunnel

The Vale Royal Railway Viaduct and the nearby cattle tunnel were both built in 1837 and designed by the world-famous 'Father of the Railways', George Stephenson. Stephenson was a self-taught Northumbrian engineer and designer of some brilliance, who rose from probable illiteracy at the age of eighteen to become one of the great figures of the Industrial Revolution. During the early 1830s Stephenson was heavily involved in managing the construction of the Grand Junction Railway, along with another eminent Victorian engineer, Joseph Locke. The Grand Junction Railway ran for 82 miles, from Birmingham, until it joined the Liverpool & Manchester Railway at Newton Junction. Its central section now forms part of the electrified West Coast Mainline.

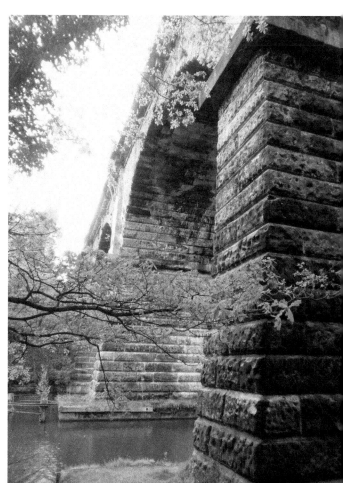

Stephenson's 1837 viaduct.

In 1837, Stephenson and Locke supervised the completion of the Vale Royal Railway Viaduct, which took the Grand Junction Railway over the River Weaver, between Davenham and Hartford. Right from the start, the viaduct was recognised as being an impressive construction. In the 1846 edition of his *Handbook for Railway Travellers*, Edward Mogg described the 60-foot-high and 45-foot-long viaduct and embankment, which cut through the lands of Lord Delamere, as being a 'handsome structure of light and elegant appearance'. Indeed, the red-sandstone viaduct still looks impressive 180 years later, with its five equal segmental arches and supporting embankment.

The fact that the viaduct cut through Lord Delamere's Vale Royal Abbey lands also led to the construction of an elaborate and certainly very unusual tunnel for cattle. In 1837, George Stephenson visited Lord Delamere to discuss the tunnel, which was probably a concession from the builders to recompense the noble lord for the inconvenience caused by the passage of the viaduct and railway through his lands. The tunnel, cut through the viaduct embankment to accommodate the easy movement of Lord Delamere's cattle, was certainly an impressive one. The Delamere coat of arms is shown at both ends of the barrel-

Overgrown entrance to the cattle tunnel.

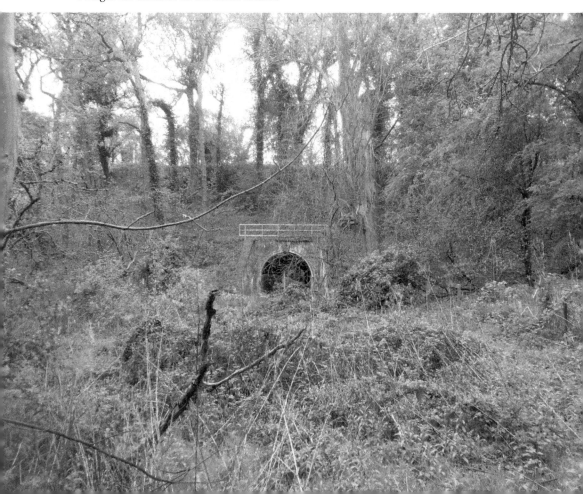

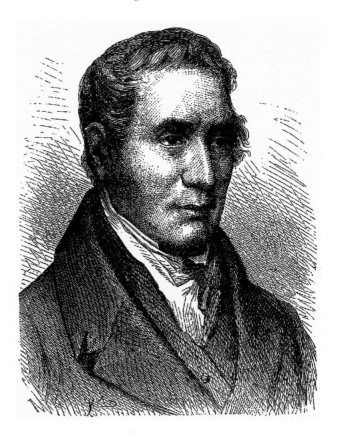

George Stephenson, by
Louis Figuier (1819–94).

vaulted 40-metre-long tunnel, which was 3 metres wide, and its semicircular
arched entrance has a 2.5-metre-thickness of brick. Lord Delamere and the
Cholmondeley family certainly had every right to feel satisfied with the efforts
of the legendary railway pioneer on behalf of their Vale Royal cattle and farmers.

15. Northwich Workhouse

Northwich Workhouse, on London Road, was built between 1837 and 1839, at
a cost of £4,530, and designed by the young and popular local architect George
Latham. The building was completed only a few years after the passage of the
1834 Poor Law Amendment Act, which established the principal of less eligibility,
whereby life for the inmates of a workhouse was designed intentionally to be
less favourable than anything which could be experienced in the outside world.
As a consequence of this doctrine, families were broken up, and children were
separated from their parents. Life was certainly tough in the workhouse, where
the old and the very young were predominant amongst the inmates. In the 1881
census, for example, of the 110 inmates in Northwich Workhouse, thirty-five were
aged sixty-five or over, and twenty-eight were aged sixteen or under.

The two-storey front of the building (as designed by Latham) contained a Guardians' boardroom, porters' lodge, and some receiving wards. The three-storey accommodation blocks were at the rear, with men housed in the southern wing and women in the northern wing. A kitchen and schoolroom were positioned in a central block. A fever hospital was added in 1850, and some proper baths were installed in various wards in 1862. In 1892, an L-shaped structure was also added to the southern side of the building.

Following the abolition of workhouses in 1930, the London Road building became a council-run public assistance institution. In 1948, the former workhouse became the Weaver Vale Old People's Home. By the time this institution closed in 1968, all but the front part of the former workhouse had been demolished. Even this surviving remnant might have been lost, had it not been for the efforts of the author Robert Westall and a few other heritage enthusiasts. By 1981, this remaining part of the Northwich Union Workhouse had been transformed into the Salt Museum, which has evolved over time into the Weaver Hall Museum of today. Memories of former workhouse days are kept alive in displays and exhibitions at the museum, which also houses an important salt industry archive. The first floor of the museum is filled with exhibits and displays, all showcasing Northwich's rich industrial past.

London Road frontage of the former Northwich Workhouse.

Above: The former Workhouse
Master's room.

Right: Displays and exhibits in the
museum.

16. St Wilfrid's Church, Davenham

St Wilfrid's Church, named after the seventh-century English saint from Northumbria, is a church with a long history. There was a church at this location mentioned in the Domesday Book of 1086, and during the twelfth century, Davenham was one of only twenty-five places in Cheshire which had both a priest and a church. Nevertheless, the church as it stands today was constructed in far more recent times, mostly between the 1830s and the 1870s.

At the dawn of the Victorian age, St Wilfrid's was seen by many as being too small to meet the needs of an expanding local population. From 1832 onwards, therefore, many of Cheshire's most distinguished architects became involved in plans to alter and enlarge the church. In 1832, Nantwich architect George Latham drew up plans for building an additional gallery at St Wilfrid's. Subsequently, between 1842 and 1844, Edmund Sharpe of Lancaster, and Edmund Paley, were heavily involved in schemes which led to the demolition of most of the church, bar the tower and steeple, and its replacement by a new and larger place of worship.

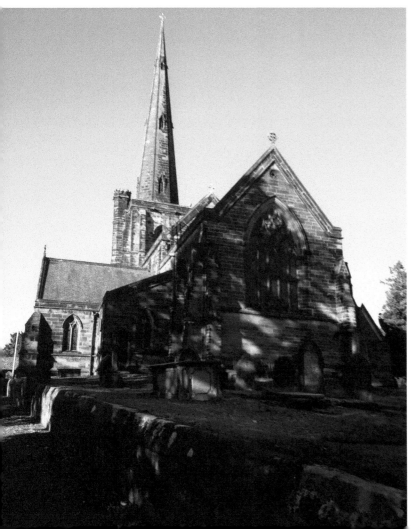

St Wilfrid's Church and spire.

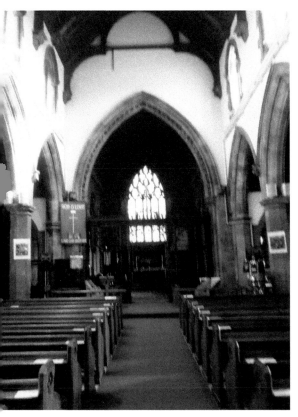
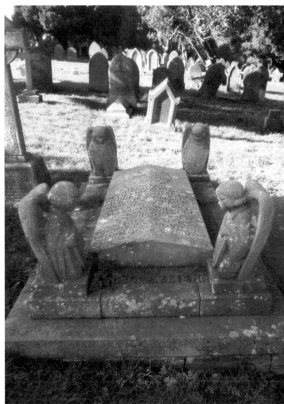

Above left: Interior of St Wilfrid's.

Above right: Allen family tomb, designed by Sir Robert Lorimer.

St Wilfrid's has been famous for its steepled tower and spire for centuries, and in 1850, both features were severely damaged by lightning. A new tower and spire were completed by 1857, under the auspices of Paley, Sharpe, and Joseph Clarke, who was the vice president of the Royal Institute of British Architects. The new 99-foot spire was 18 feet higher than its predecessor, and is the one that can still be seen today.

Two generations of the Douglas family were also involved in the church's expansion. Almost certainly, John Douglas Senior (father of the better-known John Douglas, who became perhaps Cheshire's most famous architect) was the architect paid £650 by St Wilfrid's for work undertaken in the 1830s. His son later helped transform St Wilfrid's into a Gothic Revival-style church in the early 1870s. Since the 1870s, the church has undergone further changes and modifications. Scottish architect Sir Robert Lorimer completed a notable War Memorial Chapel in 1921, and a later Arts and Crafts-style tomb for the Allen family. The spire was also damaged again, this time by an earth tremor, in 1984, but still remains defiantly aloft, at its post-1857 height of 99 feet, to this day.

17. Davenham's Victorian Primary School

Davenham's old primary school, situated at the junction of London Road and Hartford Road, was built in 1856, and children between the ages of five and eleven continued to be taught there for the best part of 140 years, until the establishment finally closed its doors for good in 1995. Before 1856, Davenham's children had been taught in school premises on Church Street, now occupied by the Davenham Players' Theatre. The new school was certainly quite a significant building, designed by the distinguished architect E. G. Paley, who was also involved in the development of nearby St Wilfrid's Church. The red-brick school building was a single-storey construction, with the addition of a two-storey schoolmasters' home, accessed via Hartford Road.

The cost of this new school, designed to educate the children of the 'poorer manufacturing and labouring classes' of the period, was just over £2,000. Part of the overall cost was met by the Church, but the major gentry families of Davenham – principally the Hosken-Harpers and the France-Hayhursts – also clubbed together to raise money for the new school. Much of the Hosken-Harper fortune, which had been used to transform Davenham Hall, had come

The former primary school, viewed from London Road.

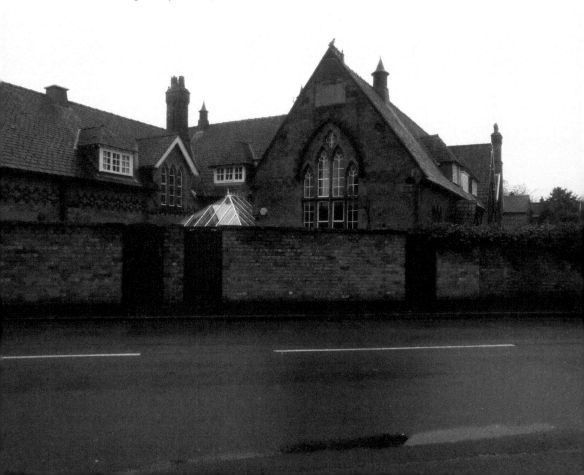

Above left: The former schoolmaster's house.

Above right: Framed list of contributors to the 1856 school.

from slave trading and plantations in Montserrat. John Hosken-Harper donated the land on which the school was to be built, together with an additional £58. By the mid-nineteenth century, the France-Hayhurst family had also benefited considerably from slave and plantation owning interests in Jamaica. The Revd Thomas France-Hayhurst, rector of St Wilfrid's, was a man of vast wealth (a millionaire many times over in modern terms) and he contributed over half the money required for building the new school.

Once established, the school gradually began to expand. The last head to live at the school was a Mr Brazier, in 1946. After this time, the schoolhouse was converted into a staffroom and kitchen. By the 1950s, seven teachers, including the head, were educating an intake of around 100 children. The cost of maintaining the school's ageing infrastructure grew considerably, and made its takeover by the local education authority (during the 1950s) probably inevitable. Kitchen facilities and playing areas were also inadequate at the old school – a new, modern school, able to accommodate a larger intake of children, was clearly needed. Once children and staff had transferred to this newly built school, on Charles Avenue, in 1995, the old school and schoolhouse was transformed into a series of private residences and apartments, and given the name Earlswood Mews. Earlswood Mews now stands, like the old school before it, right at the centre of the village, and across the road from the Bull's Head Inn.

18. Hunt's Locks

In 1856, the great Victorian engineer Edward Leader Williams beat 110 other candidates for the post, and became the Weaver Navigation Trust's new chief engineer. He set about transforming the Weaver as a river transport route, so that it could meet the challenges posed by the development of the railways. The previous twelve locks of the River Weaver were reduced to a more manageable, deeper and wider group of five locks – Hunt's Locks was one of these five new lock systems. The smaller Hunt's Lock was built in 1860 to accommodate barge traffic. The larger lock was constructed thirty years later, in 1890, and was designed to allow the passage of larger seagoing vessels along the Weaver. Both locks were made of stone, with lock gates made of steel-framed timber.

Hunt's Locks benefited from the presence of some of the latest technology of the time; for example, Lester Pelton's water turbines were installed at the site (as they were at nearby Saltersford Locks). Pelton was an American former California gold rush miner who patented a water turbine in the 1870s, which generated energy from the power of moving water, rather than water as a dead weight. Steel semaphore signals also controlled access to Hunt's Locks. This visual signalling system was a speedy, efficient method of directing vessels to either the small or large lock.

Hunt's Locks, with Northwich railway viaduct in the background.

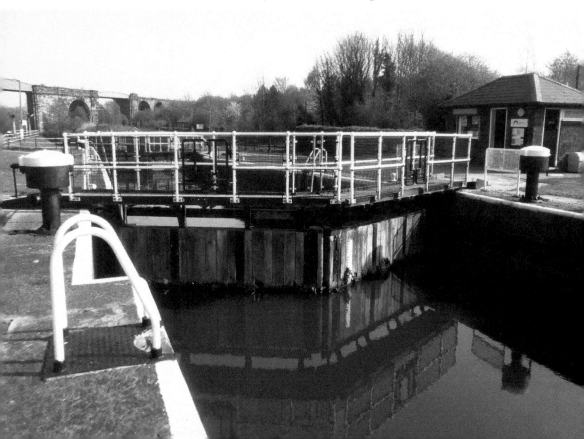

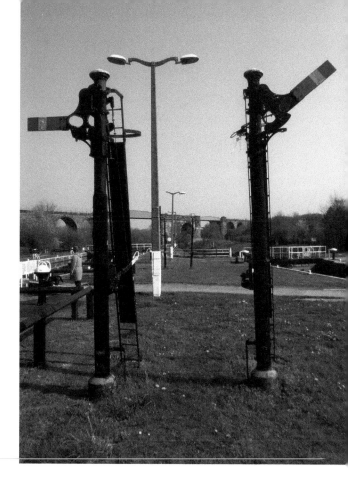

Hunt's Locks semaphore signals.

The development of Hunt's Locks, together with the other measures taken under Leader Williams' direction, certainly helped fight off competition for freight from the railways – in the year 1880 alone, 1,000,000 tons of salt was carried along the River Weaver. After he'd modernised the Weaver and its locks, Edward Leader Williams went on to design the Anderton Boat Lift, and was knighted by Queen Victoria after completing Daniel Adamson's Manchester Ship Canal. Hunt's Locks remained at the centre of much bustling commercial activity for many decades to come. Only in the aftermath of the Second World War (and from the 1950s onwards, in particular) did river traffic through Hunt's Locks and the River Weaver really begin a long and steep decline.

19. Mersey Vale

The house known as Mersey Vale on Chester Road, Hartford, was built for the prolific Victorian architect John Douglas junior in 1860. In 1874, the house was purchased by the powerful Victorian railway magnate Sir Hardman Earle, first baronet of Allerton Towers, for £1,600. The intriguingly named railway tycoon was a director of the Grand Junction (GJR) and London & North Western

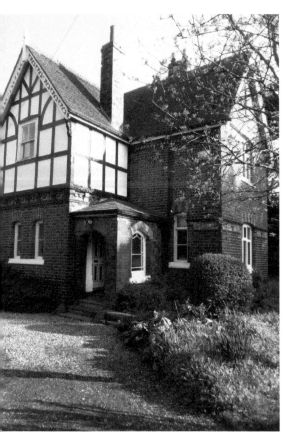
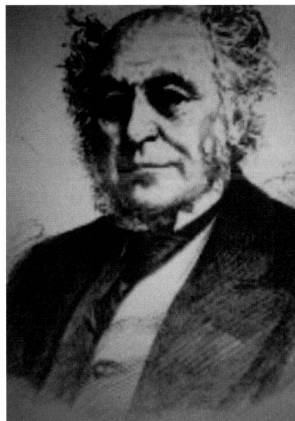

Above left: Mersey Vale, Hartford, as viewed from Chester Road.

Above right: Portrait of Sir Hardman Earle, *Illustrated London News,* 1877.

Railway (LNWR) companies. Earle only had the Hartford house for three years before he died, in Liverpool, in 1877, and he had been in poor health for some time beforehand. He may not have stayed in Hartford on many occasions, as Allerton Towers was his principal residence.

In terms of where he lived, therefore, Hardman Earle was only a peripheral figure in the Northwich area. In terms of his economic significance, however, Hardman Earle was of considerable importance. Earle was the son of a Liverpool slave trader, and he himself had considerable slave and plantation interests in Antigua. In the 1830s, the British government paid Hardman Earle well over £17,000 in compensation for his 'loss' of slaves at six Antigua plantations, as a result of Britain's ending of slavery in its colonies (a sum equivalent to nearly £2,000,000 today). Hardman Earle recirculated much of this money into railway investments, which helped companies like the GJR and the LNWR fund rail track development and create structures such as the Vale Royal Aqueduct and Hartford railway station.

20. Northwich Railway Station

The Cheshire Midland Railway was the first company to build a rail route which reached Northwich, via Knutsford, in 1863. Other routes soon followed. A line from Northwich railway station to Sandbach, via Middlewich, was completed by the London & North Western Railway in 1867. Northwich station was closed for a year between 1868 and 1869. However, in the year of its reopening a route from Northwich to Helsby was completed by the West Cheshire Railway Company. A rail line from Northwich to Winnington, intended for freight traffic, was also opened in the same year, and in May 1875 a route from Northwich to Chester Northgate was completed.

By this time, Northwich station was at the centre of a complex railway network utilised by four major private railway companies. After the Railway Act of 1921, the 120 largely loss-making private rail companies who ran the British rail network were reduced to just four main companies. Even so, Northwich railway station retained its significance, controlled as it was (via the Cheshire Lines Committee) by the London & North Eastern Railway Company, and the London, Midland & Scottish Railway. The station's key routes, particularly those to Chester and Manchester, were continued right up to and beyond nationalisation, in January 1948, when Northwich became part of British Rail's London & Midland Region. There were, though, some obvious changes. The outer face of Northwich station's southern island platform largely fell out of use, from 1960 onwards, when British Rail withdrew passenger services from the Sandbach line,

Northwich railway station entrance.

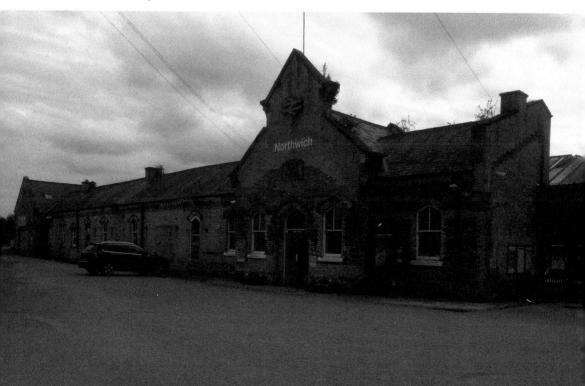

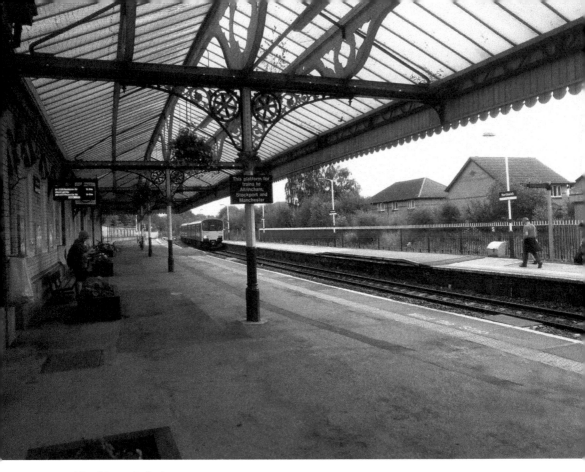

Northbound platform.

and closed Middlewich station (though the outer face continues to be used by freight traffic). Also, Northwich's locomotive depot, situated immediately to the southeast of the station, had once been a major facility for servicing steam and then diesel engines. The depot, or 'shed' had been built in 1869, and was later doubled in size, and totally rebuilt in 1948.

Nevertheless, in 1968, steam engine servicing at the facility came to an end. The practice of storing and servicing diesel engines at the Northwich depot also came to an end in 1984, and in 1991, the depot building itself was demolished.

21. St Wilfrid's Roman Catholic Church, Witton

At the beginning of the nineteenth century the Irish population of Northwich was very small indeed. However, by the mid-nineteenth century there were well over 2,000 Irish people in the town, drawn by the employment opportunities offered in the booming salt industry. These new Catholic immigrants had no suitable place of worship. A small cottage in York Buildings was used for a time, and in 1854 the Congregationalist Chapel in Cross Street was leased by Catholic

worshippers, but no permanent Catholic church existed. Collections were launched, and wealthy benefactors sought, and by 1864 enough money had been raised to purchase land for a church and a presbytery on a site in Witton Street, next to Brewery Meadow – this was to be the new St Wilfrid's RC parish church, the foundation stone for which was laid on 25 August 1864 by Canon Frith of Stockport, in a ceremony attended by well over 3,000 people.

The church building itself was designed by the Liverpool-born architect Edmund Kirby, who did most of his ecclesiastical work for the Roman Catholic Church. Kirby, during the early part of his career, acted as an assistant to Cheshire's most famous architect, John Douglas, but St Wilfrid's in Witton was one of his earlier independent commissions. The firm of Leicester & Drinkwater actually constructed the church, and did so ahead of schedule, in late 1865, at a total cost of £1545.

St Wilfrid's was officially opened in August 1866, at a ceremony attended, once again, by thousands of people, of both Catholic and Protestant persuasion. Leicester & Drinkwater also added a church school, at the end of the 1860s, which cost just £600, and is still in use today as a parish centre and community venue. The church now forms the functional central hub of the new Catholic parish of St John Vianney, created in 2013, which also includes the church of St Bede's in Weaverham, and Our Lady of Fatima in Barnton.

St Wilfrid's RC Church, Witton Street.

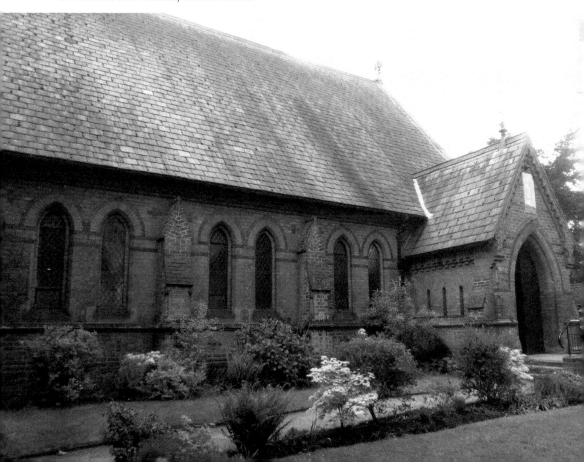

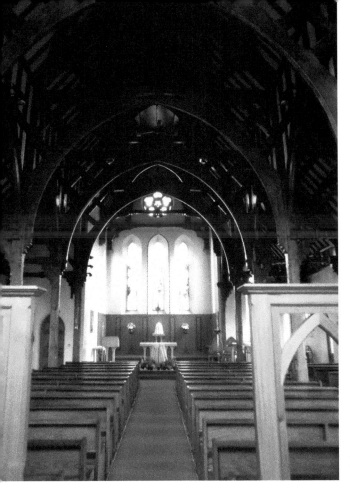

Interior of St Wilfrid's RC Church.

22. The Hosken-Harper Memorial

The memorial fountain in Davenham, dedicated to the memory of John Hosken-Harper, represents a little- known link between Northwich and the dark days of the slave trade. John Hosken was a Cornishman who married Ann, the only child of William Harper of Davenham Hall. William Harper had been a major Liverpool slave trader, with slave and plantation interests in Montserrat in the Caribbean. In return for inheriting the Davenham Hall estate, on William Harper's death, John Hosken agreed to add the name Harper to his own surname. As a result, when the slave-owning Harper died in 1815, John Hosken-Harper inherited everything, and became the new squire of Davenham Hall. John was almost certainly a slave owner in his own right, and after the British government's abolition of slavery in the colonies, in 1833, he received £714 in official compensation for the 'loss' of his slaves in Montserrat (equivalent to over £84,000 in today's money). John Hosken-Harper died in 1865, and shortly afterwards, his son was almost certainly the driving force behind the creation of the memorial still to be seen at the junction of Fountain Lane and London Road, Davenham.

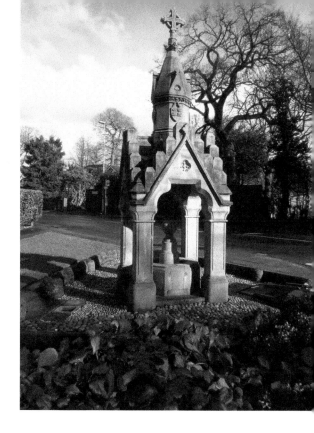

The Hosken-Harper Memorial.

23. Northwich Railway Viaduct

The Grade II listed Northwich Railway Viaduct has been a familiar part of the town's landscape for over 150 years. The half-mile-long viaduct, which has forty-eight stone arches and two wrought-iron girder bridges, traverses the River Dane, the River Weaver, and the Weaver Navigation. It was built at a height of 12 metres above water level, which was an essential requirement in a town as susceptible to flooding as Northwich. The West Cheshire Railway Company, which instigated plans for building the viaduct, became part of what was known as the Cheshire Lines Committee (CLC) in 1867. The CLC was a joint regulatory committee with overall responsibility for a vast amount of rail track in both Lancashire and Cheshire. The West Cheshire's engineers had originally planned a Northwich viaduct predominantly made of brick, which would have looked quite different to the viaduct eventually built, and which we can still see today. However, once the CLC had taken over responsibility for constructing the viaduct, its engineers planned a substantial Northwich viaduct of arches made from local red sandstone and blue brick, with wrought-iron girder-supported bridges over the waterways. It is this impressive CLC-planned feat of mid-Victorian engineering, constructed during the 1860s, which first began carrying passengers and freight (travelling between Northwich and the West Cheshire Junction) in 1869. Both goods and people continue to travel over the viaduct, to and from Chester, over 150 years later, in 2019.

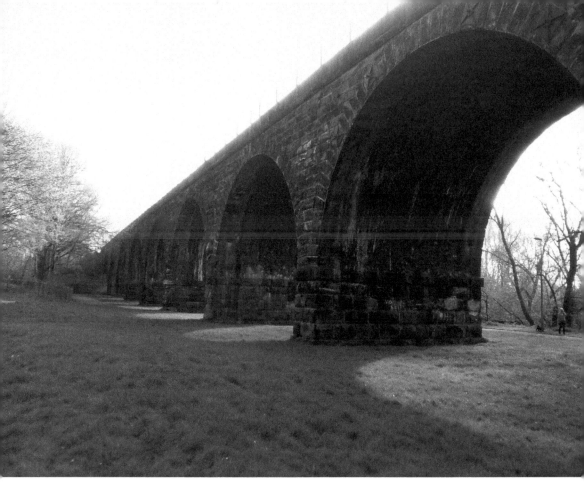

Viaduct arches east of London Road, Northwich.

24. The Bridge Inn

The 'old' Bridge Inn, close to the River Dane, on London Road, was opened in 1869. The first publican in charge of the premises was Richard Kingston, a former groom from the Altrincham area. Kingston was a married man in his mid-forties, with a wife and four daughters, when he took over at the Bridge. His time in charge was far from easy, as the building was prone to flooding, and the structure soon began to crumble as a result of subsidence. Kingston's tenure at the Bridge Inn ended with his death in 1877. His wife moved to Witton with her youngest daughter, Ellen, and the management of the Bridge Inn moved into different hands.

Further attempts at stabilising the inn's structure continued to be made, without much success, and in the early 1900s the decision was finally made to demolish the building. By 1901, the new licensed victualler in charge of the Bridge was a middle-aged former coachman from Hartford called Charles Chinnery. Business must have been reasonably good under Chinnery, because when the 'old' Bridge was demolished, plans were drawn up for a new replacement Bridge Inn at exactly

the same location. This new Bridge Inn was constructed by 1910, and it was designed in the composite, portable style so typical of many of central Northwich's buildings, with timber framing hopefully enabling the structure to withstand the effects of subsidence. In this case, however, the design proved to be something of a failure, as by 1912, evidence of the damage caused to the new structure by subsidence was plain for all to see. Chinnery's premises were closed down as a result. On this occasion, however, the building wasn't demolished. Instead, the Bridge Inn's compact lightweight structure (it weighed only 55 tons) meant that moving the building became a feasible option. In 1913, the Bridge Inn was jacked-up and moved on rollers 185 feet further along London Road, and away from the River Dane.

The building was certainly less prone to flooding and subsidence in its new location, though Chinnery's Bridge Inn public house never again opened its doors to the public. The small building still remains today, on London Road (opposite the Waitrose supermarket car park) where it provides a limited amount of accommodation, full of character and history, for a few quite lucky town centre residents.

The former Bridge Inn.

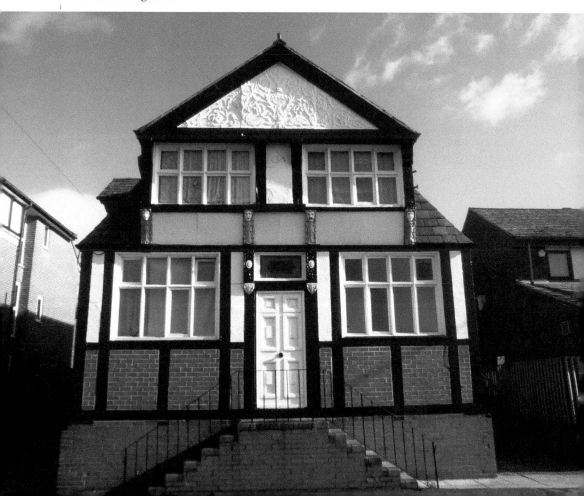

25. The Anderton Boat Lift

The Anderton Boat Lift, in Lift Lane, Northwich, was one of the great masterpieces of Victorian engineering, often described as being the 'cathedral of the canals'. The lift was designed by the prominent civil and hydraulics engineer Edwin Clark. Emmerson & Murgatroyd of Stockport began construction work in late 1872, and the Anderton Boat Lift was officially opened for business on 26 July 1875. The new construction cost over £48,000, and was designed to solve the problem of transporting goods between the River Weaver and the Trent & Mersey Canal.

A 50–60-foot gap existed between the canal and the Weaver, and prior to the construction of the Anderton Boat Lift, goods needed to be transferred either manually or via shutes. The new lift certainly speeded up the transfer of goods between the two waterways. At its busiest, the Anderton Boat Lift could raise and lower sixteen boats an hour, and it took around 2.5 minutes to either ascend or descend in the lift (in 2018 the same procedure takes roughly 30 minutes).

Between 1875 and 1908, the lift operated on basic hydraulic principles. Boats were lifted and lowered in huge watertight caissons. When boats were placed in the caissons, water displacement and gravity ensured that the vessels inside

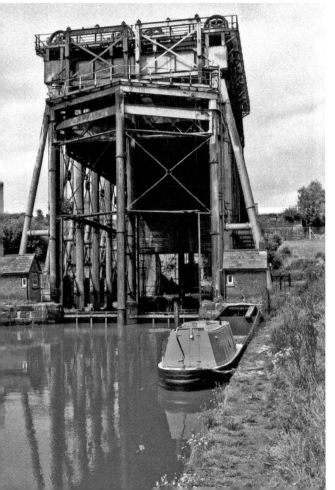

The Anderton Boat Lift prior to restoration. (Courtesy of Antony Ewart Smith)

either rose or descended. This period was an undoubted success for the lift – in 1876, 31,000 tons of goods were moved through the boat lift, but by 1906 this figure had risen to over 192,000 tons. In 1908, the Anderton Boat Lift became electrically operated, with an overall system and design created by John Saner, a civil engineer employed by the Weaver Navigation Trust since 1885.

The electrically operated lift remained in operation until corrosion forced the closure of the whole lift in 1983. Nineteen years later, in 2002, after £7,000,000 in funding, the lift reopened in its current incarnation as both a major tourist attraction and a working boat lift. Its success is shown by the fact that in 2018, over 120,000 people visited the attraction, and 3,500 boats used the Lift itself.

26. Parr's Bank Building

Parr's Bank building, on Dane Street, Northwich, was constructed in 1882, in the composite style, which allowed the structure to be jacked up and moved in the event of flooding and subsidence. Parr's had operated a bank on Dane Street since taking over the so-called 'Old Bank' previously owned by Thomas Firth & Sons, in 1865. Subsequently, Parr's Bank played a significant role in the economic expansion of Northwich during the Victorian era, financing the development of the Brunner Mond soda ash empire with loans totalling £10,000 during the 1870s.

Despite being one of the major financial centres of Victorian Northwich, the Parr's Bank building still deteriorated rapidly as a result of flooding and subsidence, which is why the bank's directors decided to finance the construction of entirely new premises, at the same location, in 1882. Parr's Bank continued to operate at these new premises until Parr's merged with the London County and Westminster Bank in 1918 (thus creating the National Westminster Bank of today). By the early 1920s, the Parr's Bank building was again being threatened by the twin dangers of flooding and subsidence, and the whole structure was raised by 7 feet and then lowered again onto a brick pier.

In 1925, the Westminster Bank sold the Parr's Bank premises to two local businessmen – T. G. Hughes and D. Wood – and moved to a new location at the nearby Bull Ring. Hughes and Wood then divided the former Parr's Bank building into three separate businesses (which became part of what was called 'Dane Chambers'). A succession of tenants followed, until Dane Chambers was reunified into a single financial consultants' business in 1984. A thorough but sympathetic renovation of the former Parr's Bank building took place, over thirteen months, prior to the official opening of the new business in 1984. During this massive architectural renovation exercise, the building was again raised by well over 4 feet, using traditional methods which the civil engineers of 1882 and 1921 would certainly have recognised. During the renovation, the substantial original Parr's Bank safe was uncovered, with a considerable void beneath it. Why the safe didn't crash through the building's none-too-firm floors remains a matter of conjecture.

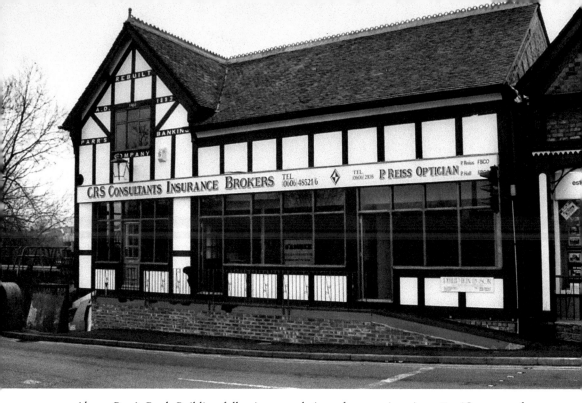

Above: Parr's Bank Building following completion of renovations in 1984. (Courtesy of CRS Consultants Ltd)

Below: The building being jacked up during renovations. (Courtesy of CRS Consultants Ltd)

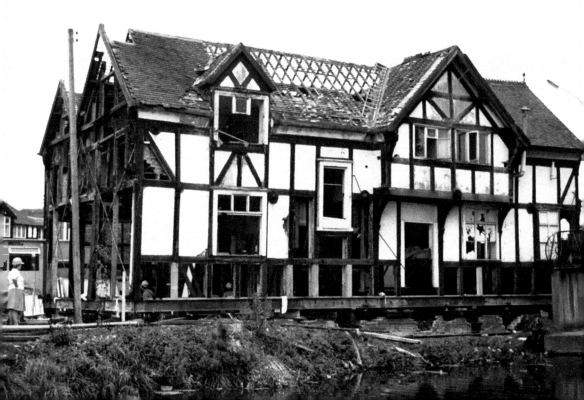

Exposed bank safe and void. (Courtesy of CRS Consultants Ltd)

27. Victoria Infirmary

Victoria Infirmary, situated at the top of Winnington Hill, on Winnington Lane, has been a hospital since 1887, when (as a voluntary hospital) it began treating accident patients. Prior to becoming a hospital, the building had been part of the Winnington Bank mansion and estate, owned by Thomas Hostage, a distinguished local lawyer, civil engineer, and clerk to the Trustees of the River Weaver.

In 1887, the mansion and estate was bought at auction by Robert Verdin, who was Northwich's MP at the time, and the elder brother of Joseph Verdin, a key member of the vastly wealthy Verdin salt dynasty. The Verdins, like the Brunners, were major benefactors to the town of Northwich, and donated considerable sums of money to various local charities and good causes. Once Robert Verdin had purchased the Winnington Bank estate, he handed it over as a gift to the town authorities, so that the area could be transformed into Northwich's new municipal park. The mansion itself was handed over by the MP so that it could be turned into a new small hospital – the Victoria Infirmary. Sadly, Robert Verdin never lived to see the fruits of his own benevolence. He died in the same year of his bequests, and neither the park nor the hospital had been opened, officially, by the time of his death.

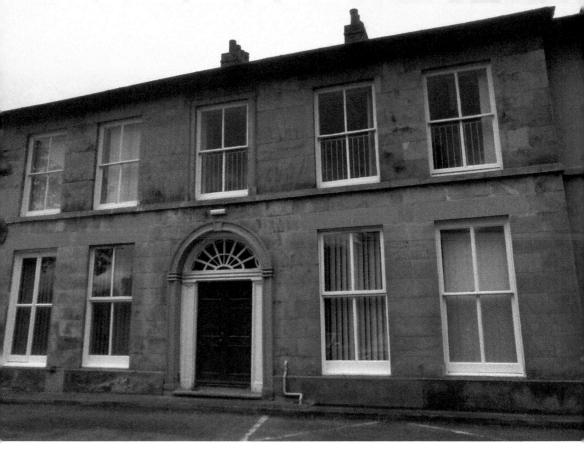

Winnington Bank Mansion.

The infirmary has been altered and expanded on many occasions during the last 130 years. A new wing was added in 1902, and further extensions were completed in 1905. An orthopaedic clinic was opened at the infirmary in 1919, and a children's ward followed in 1924. Further additions followed in the 1930s. Victoria Infirmary became part of the NHS in 1948, and the hospital is currently the home of a minor injuries unit, along with some therapy and outpatient services. The original Winnington Bank mansion, donated by Robert Verdin in 1887, continues to be used for administrative purposes by the modern hospital's managers.

28. The Greenbank Hotel

The Greenbank Hotel on Chester Road, Hartford, was one of a number of local public houses and hotels which owed their existence to the expansion of the Victorian railway network in the second half of the nineteenth century. In June 1870, a new railway station was opened at Greenbank. The Warrington brewers Greenall Whitley & Co. subsequently sought to cater for the increasing number of people using the railway station by opening a nearby public house

and hotel. However, the brewers' application to local magistrates for a liquor licence was turned down on two occasions, in 1878 and 1879, despite the fact that Greenall Whitley offered to close down three of their Northwich town centre pubs if a licence for new premises at Greenbank was approved. Final approval for the development of a new Greenall Whitley public house and hotel, near Greenbank station, wasn't given until 1893, and the Greenbank Hotel was opened, officially, the following year.

The building that opened for business in 1894 is very much the same (at least in external appearances) as can be seen today. The first proprietor of the Greenbank Hotel was the rather grandly named Charles Montgomery Chamberlain, an experienced forty-one-year-old publican, originally from Herefordshire, with a Scottish wife and five daughters – a sixth daughter was born during Charles' stay at the Greenbank.

Chamberlain was certainly aiming to attract an upper-class clientele to the new business. An 1894 advertisement for the Greenbank Hotel emphasised that it was an ideal place for gentlemen 'and their servants'. At the very dawn of the motor car age, the same advert also stressed the hotel's extensive stabling facilities, for up to twelve horses.

Front elevation of the Greenbank Hotel.

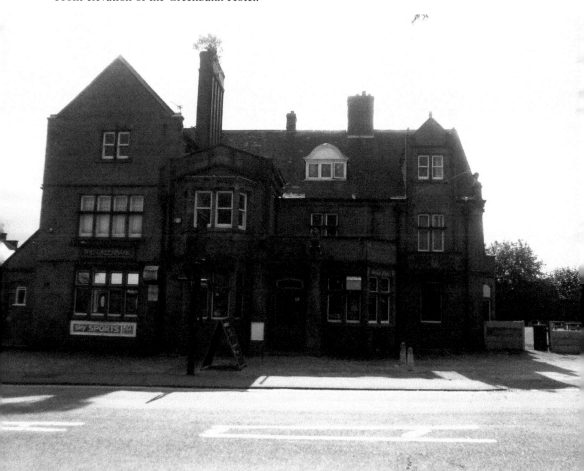

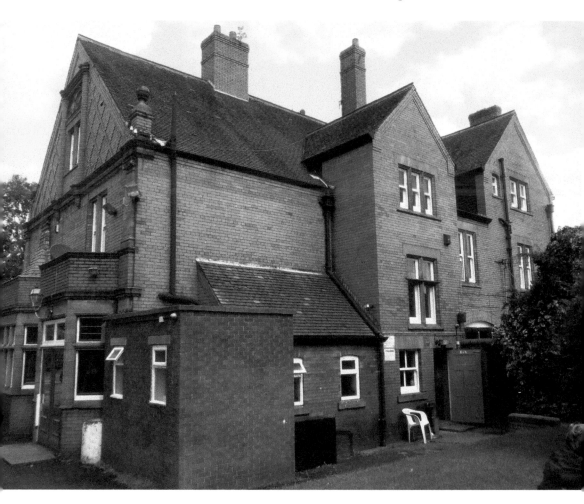

Above: Rear view of the substantial Greenbank Hotel building.

Left: Original stabling facilities at the Greenbank, *c.* 1890s.

Charles Montgomery Chamberlain stayed at the helm of the Greenbank until John Durward became the proprietor in 1903, and he in turn was succeeded by Thomas Dean Lightfoot in 1911. Lightfoot had been managing another public house in Witton until he received the call to manage the Greenbank. In subsequent years, landlords have come and gone, but the Greenbank Hotel has remained – a classic example of a late Victorian hostelry, inspired by the growth of the railways.

29. Lion Salt Works

The Lion Salt Works, in Marston, was a very late addition to the Northwich salt industry. By the time John Thompson began production at Lion Salt Works in 1894, the nearby Barons Quay mine had been operational for over forty years, and Joseph Verdin had already sold his vast salt business to the Salt Union. The business which developed at Marston, on the Trent & Mersey Canal, continued to produce salt until 1986, and was the last working open pan salt works in the UK. Surviving buildings from open pan salt works, where brine was evaporated in wide flat-based pans, supported over a fire or flue and heated from below, are very rare indeed. As such, it's not surprising that the works site was bought by the local council, once the business had closed, and that a charitable trust was formed in 1993 to conserve the site and turn it into a working museum.

Lion Salt Works. (Courtesy of Roger Kidd)

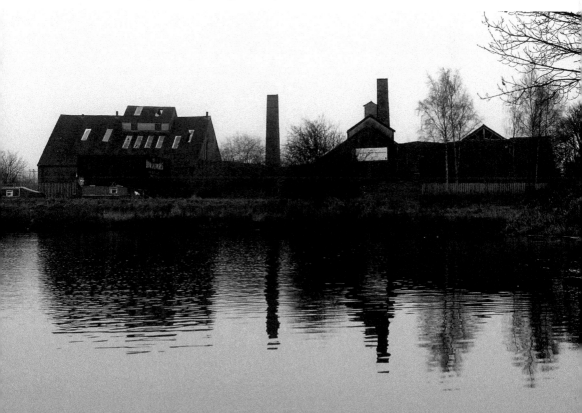

The restored Lion Salt Works of today comprises a number of historic buildings and features, including pan houses (with attached stove houses and warehouses), manager's office, smithy, salt store, railway siding, brine shaft, borehole, and a large iron storage tank capable of holding 30,000 gallons of brine.

30. The Verdin Technical Schools and Gymnasium

The Verdin Schools (two schools within one building) and gymnasium, on London Road, Northwich, provide an excellent example of Victorian philanthropy and paternalism at work in the town. The Verdin family had made their fortunes out of the local salt industry, and in the late nineteenth century, they proceeded to give some of this wealth back to the local population by funding the creation of schools, the Moulton Institute, public baths and parkland, a hospital, and other charitable concerns. Sir Joseph Verdin funded the building of the Northwich technical schools, in their entirety, from his own resources, at a total cost of around £12,000. Mary Verdin, his sister, travelled from the Verdin family home nearby, at The Brockhurst, to lay the schools' foundation stone, on 29 June 1896. The building was designed by the architect Joseph Cawley, and built by the locally

Verdin Technical Schools & Gymnasium.

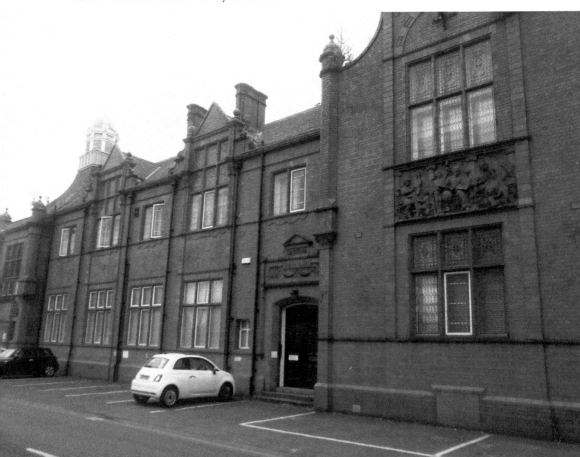

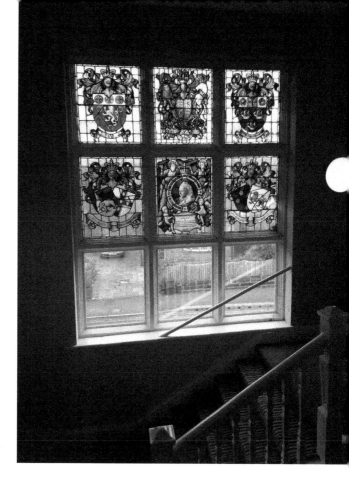

Interior stained-glass window from the former Verdin Schools.

based William Molyneux. The Duchess of Westminster formally opened the new building, with considerable fanfare, on 24 July 1897, in a ceremony designed to coincide with Queen Victoria's Diamond Jubilee celebrations.

The schools launched on this date at London Road were certainly housed within a very impressive and appropriately planned building. The substantial stained-glass interiors celebrated the achievements of the British empire, and highlighted some of the important figures involved in the development of science and learning. The art rooms inside were well lit by large windows, and the technical workshops were supported by solid concrete floors. The gymnasium was also of an impressive size (60 feet by 31 feet) and of double height, enabling rope work, vaulting and other gymnastic exercises to take place. A viewing gallery was constructed so that special displays of gymnastic prowess could be observed by visiting dignitaries. Outside, the building was also adorned with Jabez Thompson's finest and most detailed terracotta panels, illustrating classical scenes of learning and industry. As a whole, the building remains in a good state of preservation, both internally and externally. For most of the 120 years since its construction, the building maintained its original function as a place of learning for children, and later for students at the Mid-Cheshire College. In 2013, however, the building was converted into a series of private flats and apartments now known as Verdin House.

31. Winnington Park Recreation Club

The Brunner Mond chemical company was, for its time, quite conscientious in looking after the social and recreational needs of its employees. In November 1897, the so-called Winnington Club was opened for the company's top managers and directors. The club allowed a small number of men (fewer than twenty) to drink, play billiards and socialise in Brunner and Mond's former home. Such facilities were not available to the vast majority of the Brunner Mond workforce at Winnington. Instead, only a small bowling green shed had been provided for workers' recreational pursuits, and this building had been in use since 1890. To rectify this situation, John Brunner and Ludwig Mond sanctioned the building of a new pavilion to house an extended recreational club for the vast mass of its Winnington Works employees, at Winnington Park. William Wood, a local builder, was commissioned to build the new pavilion.

The construction of the new club was announced with great fanfare, at a grand Winnington Park fete held on 19 July 1897. The fete was organised to celebrate the twenty-fifth anniversary of the launch of the Brunner Mond Winnington plant, and invitations to attend were issued to all Brunner Mond employees, their families and friends, a few days before the actual event took place. Tightrope walkers, clowns and clog dancers provided entertainment at the fete, and tug of war competitions were also held. Three fireworks were fired into the sky to announce to all attendees when tea was ready. The new Winnington Park Recreation Club (WPRC) looked, to some degree, like a scaled-down version of the nearby Tudor wing of Winnington Hall, with its black and white timber design. From the very start, sport was a major

Front view of Winnington Park Recreation Club.

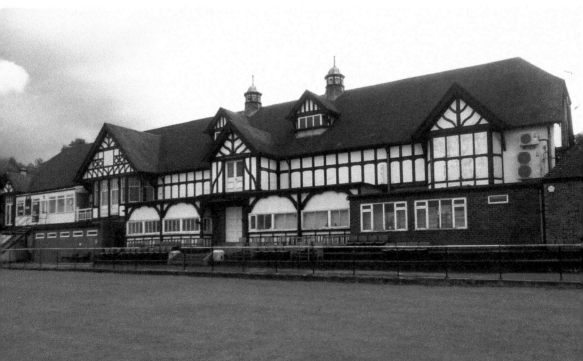

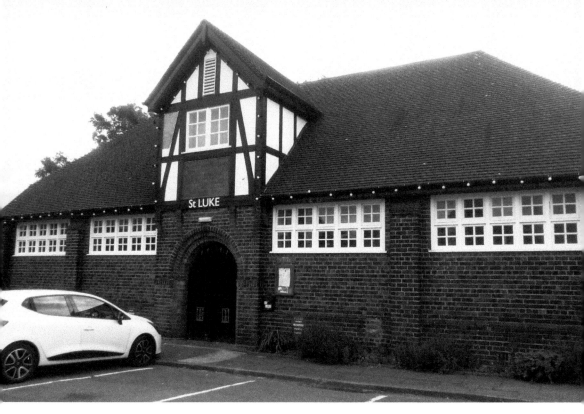

The club library (now St Luke's).

feature of the new club, and Winnington Park became the home of a number of very successful football, cricket, bowls and other sporting teams.

The club was extended in 1923, with the addition of a library, and there were further facilities added in 1937. Indeed, the 1930s were the heyday of the WPRC. Brunner Mond had become part of Imperial Chemical Industries (I.C.I.) and the club had over 5,000 members drawn from I.C.I.'s Winnington plant alone. However, as the number of I.C.I. workers at Winnington declined, the WPRC had to accept non-members. Today, over 120 years after the building was originally constructed, and long after I.C.I.'s departure from the vicinity, the WPRC continues to provide hospitality, entertainment and recreational opportunities for a wide range of local people.

32. Swing Bridges of Central Northwich

The three Northwich swing bridges over the River Weaver – the Hayhurst, the Town and the Winnington Turn Bridge – were all designed by John Saner, who was the chief engineer to the River Weaver Trustees, from 1888 onwards, and later the General Manager of the River Weaver Navigation Trust. The Hayhurst, Town and Winnington Turn bridges were amongst the first electronically operated bridges ever built. The Hayhurst (originally called the Navigation Bridge) was

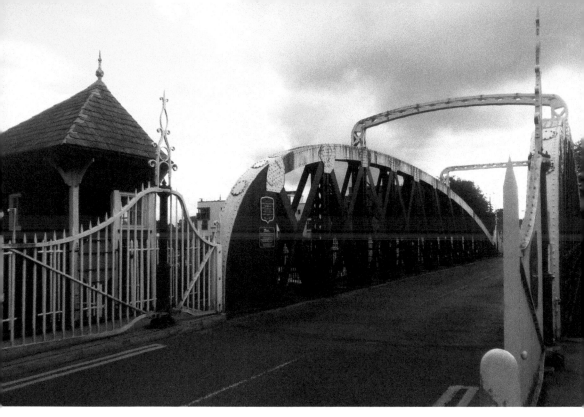

The Hayhurst Bridge, with control box.

the first to be completed, in 1898, but the Town Bridge soon followed in 1899. However, both bridges were opened formally, together, on 20 July 1899. The Winnington Turn Bridge (sometimes called the Weaver Navigation Swing Bridge) was only completed a decade later, in 1909, and was the replacement for an earlier unsatisfactory bridge, which had been built in 1901.

Some notable companies were involved in the construction of the three bridges. Andrew Handyside & Co. of Derby were heavily involved in the building of the Hayhurst and the Town bridges. Yarwood's, the local shipbuilders, also played a significant role in the construction of the pontoons on which the Hayhurst and the Town Bridge both sat. Mather & Platt supplied the electrical works for the Hayhurst and Town bridges, and the same company went on to supply motors for the swing system and locking wedges at the Winnington Bridge.

The bridges were technological marvels of their time, and all three remain key parts of modern Northwich's transport infrastructure. Age has, however, begun to catch up with the structures. All three have been repaired and reinforced at various times during the past century. As early as 1923, the Town Bridge was closed for seven months for repairs. In 1998, the same bridge was upgraded to accommodate 40-ton vehicles, and to repair corrosion. Winnington Bridge also allows only single-lane traffic, which can cause considerable tailbacks and congestion. Discussions about the construction of a new and wider bridge at Winnington have gone on for some time.

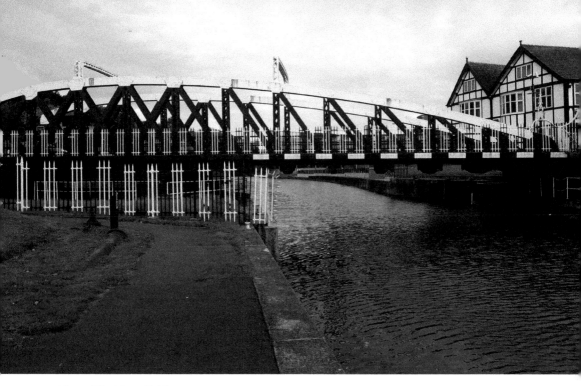

Above: The Town Bridge.

Below: Winnington Turn Bridge. (Courtesy of Stephen McKay)

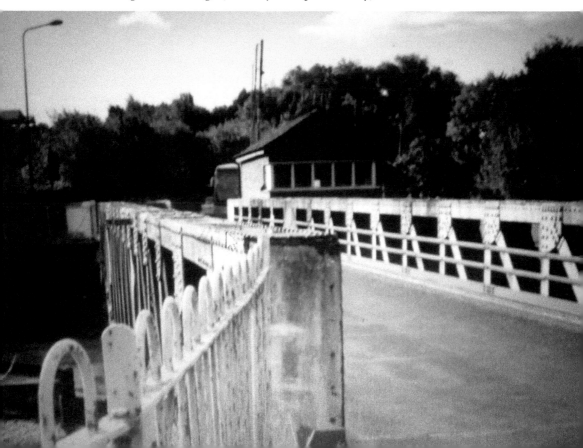

33. Nunsmere Hall

Nunsmere Hall, on the outskirts of Northwich, is one of the more modern of the grand houses dotted around the area. It was built in 1900 for Sir Aubrey Brocklebank, a Liverpool shipping magnate and chairman of the Brocklebank Shipping Line, which had been in existence since the early eighteenth century.

During the First World War, Brocklebank ships played a crucial role in maintaining Britain's vital Atlantic supply lines, transporting food and war materiel across the sea from North America, despite the menacing attentions of German U-boats. Probably a sixth of the total Brocklebank fleet was sunk whilst engaging in these activities. After the end of the war, the Brocklebank Line merged with Cunard. Despite this, Sir Aubrey maintained his strong maritime interests and connections. Whilst living at Nunsmere Hall with his wife, Grace, he was closely involved in planning the design of the *Queen Mary* passenger liner. Sir Aubrey died before the *Queen Mary* was launched, but his son John, along with Grace Brocklebank, continued to live at Nunsmere Hall until the outbreak of the Second World War, when the house was transformed into a military hospital.

The family's significant maritime links were maintained by John Brocklebank, when he became chairman of Cunard in 1959. During the early 1960s, as Cunard's chairman, John Brocklebank began the planning process which led to the eventual launching of the *Queen Elizabeth II* passenger liner. By the 1980s, the Brocklebanks' Nunsmere Hall had been converted into a rather stylish thirty-six-bedroom country hotel, which it still is today. Perhaps its most famous resident was the former Prime Minister Margaret Thatcher, who wrote two volumes of her memoirs whilst living at Nunsmere Hall, during the 1990s.

Nunsmere Hall. (Courtesy of Nunsmere Hall).

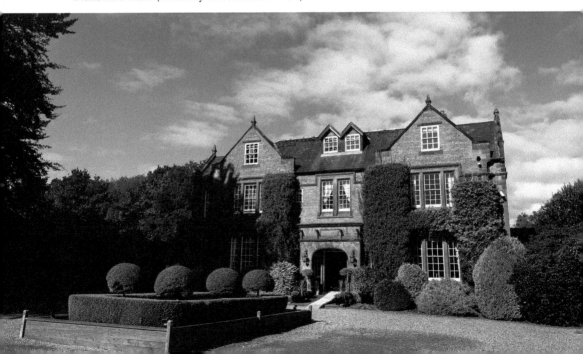

Above: The hotel lounge. (Courtesy of Nunsmere Hall)

Below: Nunsmere Hall gardens, much admired by Margaret Thatcher during her time as a resident at the hotel. (Courtesy of Nunsmere Hall)

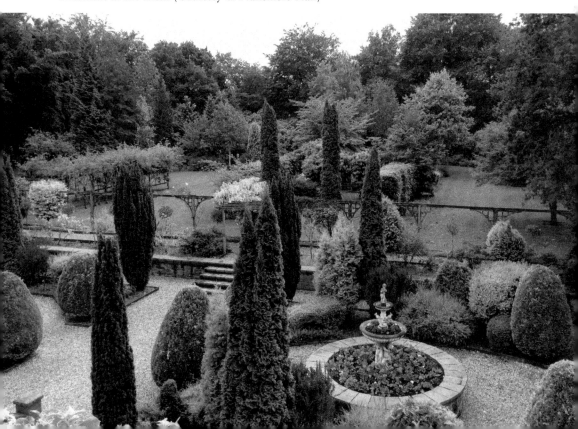

She apparently relished the solitude offered by the hall's 10 acres of manicured lawns, and the large lake which surrounds the property on three sides, and she took the opportunity to write *The Downing Street Years*, in 1993, and *The Path to Power*, in 1995. A picture of Britain's first female prime minister, and Nunsmere Hall's most famous recent occupant, is on permanent display in the hotel's lounge.

34. The Salty Dog

The Salty Dog public house and music venue is based at No. 21–23 High Street, Northwich, and has one of the most interesting, immaculate exteriors of any of the traditional black and white buildings to be found in the central part of the town. The ground floor of the building is the preserve of the Salty Dog. Upstairs, however, there is a rest room for drivers based at the nearby bus interchange, which is accessed via the Watling Street Chambers entrance. The exterior of the building, at this first-floor level, is adorned with three carved monsters. At either end of the building's frontage, two bright, well-preserved carvings representing a nightwatchman and a town crier can also be seen. In between these two figures, a

The Salty Dog public house and music venue.

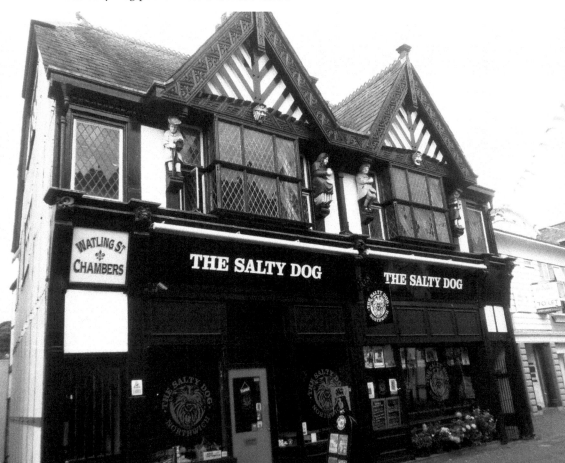

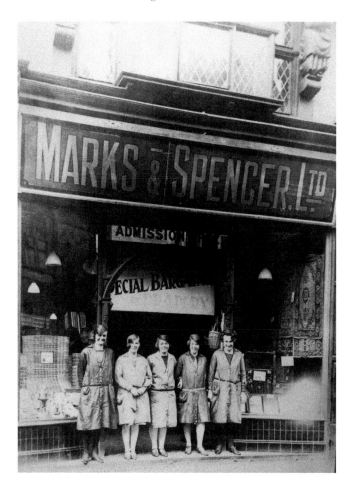

Marks & Spencer's
c. 1930.

man and a woman are depicted, carrying mugs and plates – these figures are often referred to as being the mayor and his wife.

The building now occupied by the Salty Dog and bus drivers' rest quarters has quite a long documented history stretching back to at least 1908, when Marks & Spencer's opened its first Northwich Penny Bazaar shop in one part of the current public house. Nearly ninety years ago, Marks staff were photographed underneath the same distinctive carvings of the nightwatchman and the mayor's wife that passers-by can see today. Marks & Spencer's stayed at this location until 1933, when the branch moved further up Witton Street to larger premises now occupied by Clinton Cards. Marks stayed here for nearly sixty years, and business obviously boomed as the store expanded outwards to encompass space occupied subsequently by Greenwood's, the tailors, and Adams. In 1992, Marks & Spencer's moved to even larger premises, on Leicester Street, which had been occupied previously by Sainsbury's. The store stayed at its Leicester Street base for over twenty-seven years, until it finally closed down on 17 August 2019, thus ending a 111-year association between Marks & Spencer's and the town of Northwich.

35. Northwich Public Library

The public library which can be seen today on Witton Street is the second library to be based at roughly the same location in central Northwich. The first library was financed by Sir John Brunner, and opened with great ceremony in July 1885. The building was an impressive one, with a 30-foot glass and wood domed entrance hall and, in 1889, it became the home of the Northwich Salt Museum. During the 1890s the building was damaged repeatedly by the effects of subsidence and, in 1907, the entire structure was demolished. A new, very different library emerged in 1909, again financed by John Brunner, designed by AE Powles, and built by Wood's of Hartford. The building was designed in the classic black and white Tudor style, via the composite method, which ensured that in the event of future subsidence, the whole structure could be lifted and moved to another location. The new library was opened by the Liberal government's Minister of Education, Walter Runciman. Like the previous library, the new building had office space, and living accommodation for a resident Head Librarian (space utilised in more recent times for administration and storage).

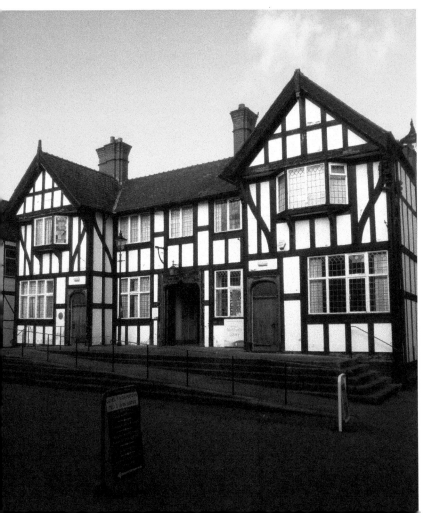

Northwich public library, opened in 1909.

36. Dock Road Edwardian Pumping Station

The Dock Road Pumping Station, which can be accessed from Weir Street, just off London Road, in central Northwich, represents a fine example of Edwardian era engineering. The circular one-storey construction, completed between 1910 and 1913, is itself rather attractive and ornate, with rustic brick, a crenelated parapet and seven eight-pane windows set around the building.

Inside the station sit two large engines made by Crossley Bros of Manchester, in 1910. The Crossley brothers were famous teetotal siblings who refused to sell their engineering products to breweries, and their company still exists today as part of the Rolls-Royce group. Two large pumps, made by the Hayward Tyler engineering company in London (also in 1910) were also installed in the station. These pumps were at the cutting edge of technology in 1910, and they were supplied by a company, founded in 1815, which already had a strong reputation for technical skill and innovation.

By the beginning of the twentieth century, the expanding town of Northwich needed better and more effective sewage and sanitary arrangements to be put in place. The town's first sewers had pumped effluent straight into the River Weaver, which presented obvious and major dangers to public health. As a consequence, the Wallerscote Sewage Works were built in 1902, to try and improve the situation. Although the provision of Wallerscote did have a positive effect, some parts of

Exterior view of Dock Road Pumping Station.

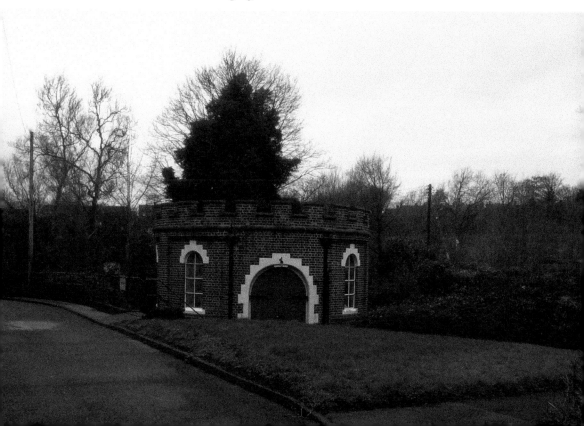

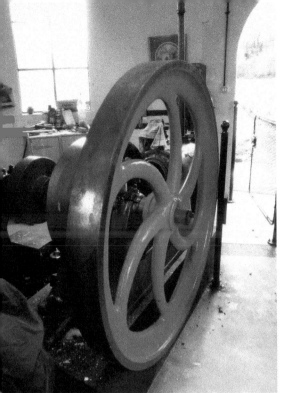
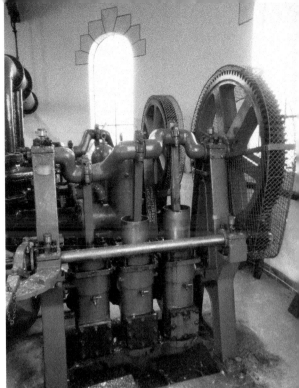

Above left: Original Edwardian machinery – still in working order.

Above right: Hayward-Tyler machinery.

Northwich were too low-lying to have their sewage pumped to the Wallerscote Works. Further measures still needed to be taken. This led the Northwich Urban District Council to commission the building of the Dock Road Pumping Station in 1910. The new station was designed to intercept sewage before it made its way into the Weaver. Instead, the station made sure that waste was pumped across the river, up to the top of Castle Hill, and then onto Wallerscote. The Dock Road Pumping Station did this task successfully for the next sixty years. At the height of its usage, the small Dock Road station could pump 9,600 gallons of waste matter every hour. In the 1970s, however, a new pumping station was built next to the old Edwardian structure, and this new facility's electric pumps could process well over 36,000 gallons of waste matter every hour.

37. The Penny Black

This Witton Street building, now the home of the Penny Black public house, was originally the location of Northwich's main post and sorting office. The building was commissioned by the Post Office, though the actual building work itself was completed by the Ministry of Works between 1914 and 1915. At this time, both the Post Office and the Works Ministry were government departments, and their collaboration in building projects was sometimes the cause of tension and confusion.

However, this was certainly not the case with Northwich's main post office. The building, designed by Charles Wilkinson, proved to be something of an architectural gem. It's three storeys high, with an attic, tiled roof, and ornately decorated frontage. In addition, the building was another of Northwich's composite structures, designed with timber frames, recessed panelling, steel ring beams and jacking points, which allowed the whole structure to be lifted and moved in the event of subsidence.

The building lay empty during the First World War, and only opened to the public in 1919. At the time of its opening, the main post office was the largest liftable building in the town – it was far taller than any of the immediate buildings around (in fact the structure still dominates the surrounding architectural landscape) and moving it would surely have been a major engineering and logistical exercise. Fortunately, the need never arose. The main post office fulfilled its sorting and postal functions more than adequately for eighty years, until the property was sold by the Royal Mail business in the 1990s. Like many other former large post offices, the building was converted into a public house. The large, open ground-floor spaces provided by a post office made conversion into public houses quite easy and straightforward. The former post office continues today as the Penny Black public house. Its name, harking back to Rowland Hill's development of the world's first adhesive postage stamp, is a constant and obvious reminder of the building's postal past.

The Penny Black public house.

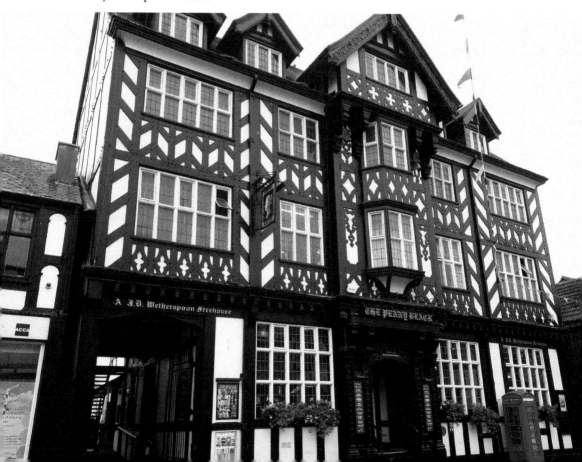

38. RAOB Building

The RAOB Building on Witton Street in Northwich is one of the best-preserved composite Tudor-style portable structures in the town. The structure was built by E. W. Bostock in 1913, and designed by the well-known architect J. Cawley. The building acquired its name from the Royal Antediluvian Order of Buffaloes (RAOB) charitable organisation, which occupied the premises between 1977 and 2013. The Buffs, as RAOB members were called, engaged in good works within the local community, and were organised rather like a Masonic Order, with Minor, Provincial and Grand Lodges.

Long before the Buffs came to Witton Street, the RAOB Building had been the home of the Constitutional Club, and of the Northwich Conservative and Unionist Association. The building was once vast, covering over 4,800 square feet, with cellars, saloon areas, two function rooms (one with a stage) a viewing gallery at the rear, and an upper-storey balustraded balcony. These spaces and facilities made the building an ideal location for clubs and political parties. However, after the Buffs left in 2013, the building remained empty for a while, before being converted into a mixture of private apartments and offices.

The RAOB Building.

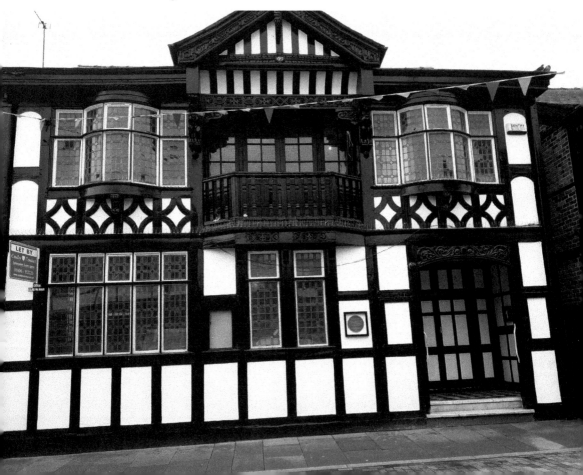

39. Sandiway Golf Club and Clubhouse

Northwich's great chemical company Brunner Mond played a vital role in the establishment of the Sandiway Golf Club, on Chester Road, Sandiway, in October 1920. Financial support from the company helped ensure that the new golf club had sufficient resources to lease 115 acres of land at Sandiway, from Lord Delamere, on which to build the new course. Edward (Ted) Ray then set about designing one of the very best golf courses in the area. Although golf competitions took place at the new venue from 1922 onwards, an appropriate clubhouse was still needed, and Brunner Mond again came to the rescue by giving the new club one of its properties, known as the Bachelors Hall, in 1923. In return for its financial help, Brunner Mond was allowed to appoint the club's first secretary, and five out of nine of the club's golf committee members.

The company certainly played a significant role in the early history of Sandiway Golf Club. Many of its senior managers lived in nearby Hartford, and made frequent use of Sandiway's facilities. Indeed, Maxwell Woosnam, who was a staff manager at Brunner Mond, and secretary of its exclusive Winnington Hall Club, became Sandiway's Club Captain in 1929. Woosnam was one of Britain's greatest ever amateur sportsmen, winning the men's doubles Olympic tennis title in 1920, and becoming the men's doubles champion at Wimbledon the following year. He also played for Chelsea, Manchester City and England as a footballer, and was a superb scratch golfer, who set a course record score of seventy-four on the original 1920 layout of Sandiway's golf course. He also became a Board member of I.C.I. (which superseded Brunner Mond) and helped ensure a continued close relationship between the golf club and the local chemical industry.

Sandiway Clubhouse and golf course. (Courtesy of Sandiway Golf Club)

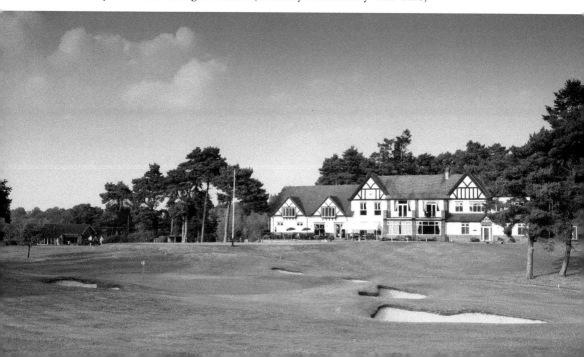

Max Woosnam, 1929. (Courtesy of Sandiway Golf Club)

In more recent times, the club survived the challenges posed by the Second World War, and the building of the Northwich Bypass road. The land on which the clubhouse and course stands is now owned on a freehold rather than a leasehold basis, and the Clubhouse itself has been expanded to include a golf shop and more catering facilities. The building now looks very different indeed from the old Bachelors Hall inherited from Brunner Mond in 1923.

4c. Regent Street and Moulton War Memorial

In 1900, the population of Moulton village, a few miles to the south of Northwich, was just over 1,000. During the 1880s, the Salt Union – which comprised an amalgamation of previously independent salt mines – had built at least 100 terraced cottages in Moulton to house its salt workers, and houses in Regent Street were part of this development. Prior to the inception of the Salt Union in 1880, the Verdins were really the 'salt kings' of the area, and they dominated the village, together with the France-Hayhursts (who were described as being Moulton's

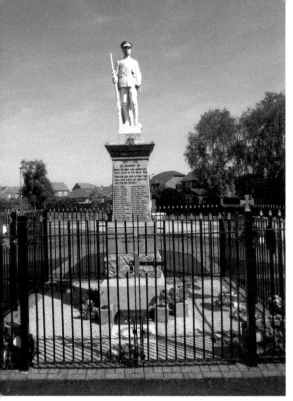

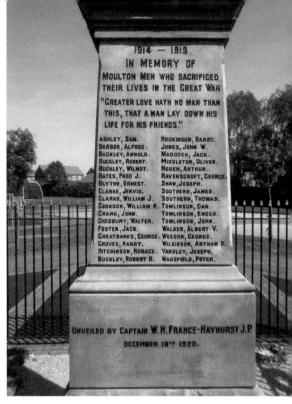

1914 — 1919

IN MEMORY OF
MOULTON MEN WHO SACRIFICED
THEIR LIVES IN THE GREAT WAR

"GREATER LOVE HATH NO MAN THAN
THIS, THAT A MAN LAY DOWN HIS
LIFE FOR HIS FRIENDS."

ASHLEY, SAM. HODKINSON, HARRY.
BARBER, ALFRED. JONES, JOHN W.
BUCKLEY, ARNOLD. MADDOCK, JACK.
BUCKLEY, ROBERT. MIDDLETON, OLIVER.
BUCKLEY, WILMOT. NODEN, ARTHUR.
BATES, FRED J. RAVENSCROFT, GEORGE.
BLYTHE, ERNEST. SHAW, JOSEPH.
CLARKE, JERVIS. SOUTHERN, JAMES.
CLARKE, WILLIAM J. SOUTHERN, THOMAS.
COOKSON, WILLIAM H. TOMLINSON, DAN.
CRANK, JOHN. TOMLINSON, ENOCH.
DIDSBURY, WALTER. TOMLINSON, JOHN.
FOSTER, JACK. WALKER, ALBERT V.
GREATBANKS, GEORGE. WEEDON, GEORGE.
GROVES, HARRY. WILKINSON, ARTHUR F.
HITCHINSON, HORACE. YARDLEY, JOSEPH.
BUCKLEY, ROBERT H. WAKEFIELD, PETER.

UNVEILED BY CAPTAIN W. H. FRANCE-HAYHURST J.P.
DECEMBER 18TH 1920.

Above left: Moulton War Memorial.

Above right: Names of the Moulton fallen from the First World War.

Below: Regent Street, Moulton, as viewed from the War Memorial.

'lords of the manor' in Kelly's 1896 *Directory of Cheshire*). The land on which the village's war memorial is situated was also donated by the Salt Union. The memorial, designed by Samuel Welsby, and unveiled by Captain France-Hayhurst in 1920, is an elegant one, standing over 23 feet high (7 metres) with a marble statue of an archetypal First World War 'Tommy' at its centre.

Few villages deserve such a fitting and impressive memorial more than Moulton. Moulton, in the early twentieth century, was undoubtedly tiny and predominantly working class, full of ordinary salt workers and their families. Yet despite this, the memorial records the names of thirty-four men from the village who were killed in the Great War, with the addition of twelve men who were killed in the 1939–45 conflict. Some of the men recorded here were undoubtedly born and raised within a very short distance of the memorial that was later to bare their names. John 'Jack' Foster, for example, has no known grave. He was a corporal in the South Lancashire Regiment, and was killed on the Western Front in 1918. Jack was born at No. 74 Regent Street, just across the road from where the memorial was later to be situated. He was the son of a salt boiler, and worked as a labourer until he joined the army. The place where he was born and raised, and the memorial which records his name, are but a few yards apart, and remain bound together inextricably by the bonds of war.

41. The I.C.I. & Alkali Division War Memorial, Winnington Works

The War Memorial, unveiled on 11 June 1921, at Winnington, was unusual in a number of respects: though the inscriptions on the Portland stone obelisk (surmounted by a bronze lantern) have faded over time – probably as the result of bad weather, pollution and overzealous washing – the four lions couchant at the base of the monument remain remarkably impressive and lifelike. This Brunner Mond/I.C.I. memorial is also unique in other ways: the other company war memorials – at Sandbach, Middlewich, Silvertown and elsewhere – only list the names of the fallen from their particular site or office. However, as befits a memorial at the founding site of the Brunner Mond (and subsequently I.C.I.) business empire, the Winnington memorial records the names of all 291 former company employees killed, from across the country, during the First World War, with some additions made for those killed in the Second World War.

The memorial was also designed by Darcy Braddell, a renowned architect with strong connections to both the Brunner Mond company and the Mond family in particular. Braddell was clearly the architect of first choice for the company, and for Sir Alfred Mond, who later became the first chairman of the massive I.C.I. conglomerate. The architect redesigned the internal layout of Winnington Hall in 1920. In addition, he was responsible for designing Melchett Court, the Mond family residence in Hampshire, and the Mond family mausoleum in Islington and St Pancras Cemetery, in London.

Above and right: I.C.I. War Memorial with lions couchant at the base.

42. Plaza Cinema

The former Plaza Cinema, on Witton Street, which became a bingo hall between the 1960s and 2011, is surely one of the most distinctive and unusual buildings still to be found in central Northwich. Whereas many of the town's traditional buildings are of black and white timber, or terracotta brick, the Grade II listed Plaza boasts an ornate, brightly coloured neoclassical exterior. It also has a sumptuous interior, with balcony seating of original mottled crushed velvet, some carpets which were laid in the 1920s, and a double-sized auditorium. A well-preserved art deco-style balustrade also leads visitors up the stairs and onto the balcony seating area.

The original building was designed for Cheshire County Cinemas Ltd by William and Segar Owen of Warrington, who were architects of distinction, and played a significant role in the development of nearby Port Sunlight. The building itself was encased within a steel frame, perhaps as a protection against the subsidence which caused so many other notable Northwich buildings to collapse. The Plaza opened to the public in December 1929, with a showing of the Al Jolson film *The Singing Fool* and was the first cinema in the town to show a picture with sound, rather than just a silent film. Cinemagoers who wanted seats in the main stall area of the auditorium entered the building via a side entrance, and purchased their tickets at the small pay office, which exists in pristine condition to this day. Those members of the public who wanted to watch Al Jolson and subsequent films from the balcony seats were given access to the Plaza via its main Witton Street entrance.

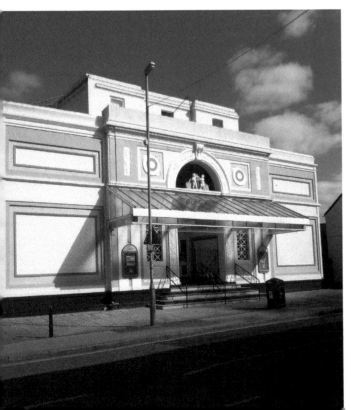

The former Plaza Cinema, opened in 1929.

Above left: Original Plaza Cinema ticket office.

Above right: Original 1920s seating inside the cinema.

In the pre-television age, when going to the movies was immensely popular and relatively cheap, up to five different cinemas once operated in Northwich, though some lasted much longer than others. By the time the Regal Cinema closed in 2007, none were left. A plush new cinema complex did open in 2016, as part of the Barons Quay development, but it certainly lacks the architectural uniqueness and quirky, opulent interiors of a fabulous old cinema like the Plaza in Witton Street. Since it was opened in 1929, the Plaza has been owned by members of the same family – the Godfreys – who have managed the venue through its cinema and bingo hall days. In recent years, the building has been utilised as a venue for live music, and some prestigious acts and artistes have appeared on stage at Northwich's rather unique former cinema.

43. Winnington Research Laboratories

Both Brunner Mond Ltd, and its successor I.C.I., which swallowed up the Northwich-based business in 1926, had a strong belief in the importance of scientific research. Ludwig Mond, co-founder of the Brunner Mond chemical empire, had a private laboratory in his own house at The Poplars, in St John's Wood, London. This commitment to scientific development was bequeathed to I.C.I. who,

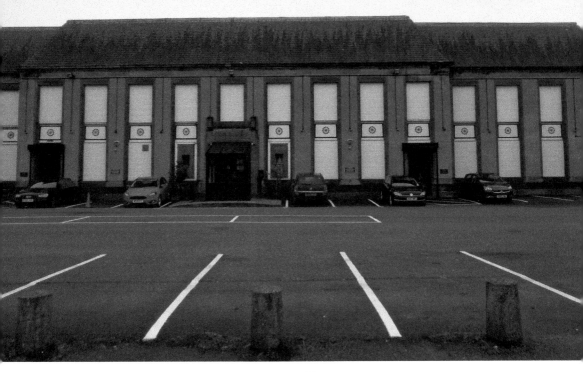

I.C.I.'s Winnington Research Laboratories Building.

by the early 1930s, had established one of the finest research laboratories in the country, on Winnington Lane, and near the vast I.C.I. Winnington and Wallerscote Island plants.

The building in which I.C.I.'s research took place was a plain and innocuous one (now occupied by a sauna). Nevertheless, the discoveries which took place there were of real historical significance. During 1933, two research chemists at the laboratory – Reginald Gibson and Eric Fawcett – inadvertently discovered polyethylene, better known as polythene. Unfortunately, the scientists were unable to replicate, safely, the results of the experiment. Facilities were improved in the building, but it wasn't until 1935 that M. W. Perrin was able to produce polythene in powdered form. The substance proved to be vital as radar insulation during the Second World War. Since then, polythene has been used in a vast number of ways, but at considerable environmental cost.

44. Davenham Players Theatre

The village of Davenham acquired its own small theatre in May 1941, when a group of local enthusiasts formed the Davenham Church Players Theatre, based at St Wilfrid's Church Hall, on Church Street. The company's first production was a performance of Dorothy L. Sayers' 1937 medieval drama *Zeal of Thy House*. Many other productions have followed since then, though the company left the church hall and moved to nearby No. 59 Church Street during the late 1960s.

During its early days, the players' relationship with St Wilfrid's meant that those with key responsibilities in the theatre really needed to be regular churchgoers and communicants. Some felt that this restricted the theatre's development, and so new premises were urgently sought. Rising church hall rental charges also made a move imperative. The property at No. 59 Church Street, which became the new home of the Davenham Players Theatre, has a long history stretching back to at least the middle of the eighteenth century. In 1783, for example, it became a schoolhouse, educating children previously taught in a room in St Wilfrid's Church belfry. In more recent times, the premises became the base for a constitutional club, and from the late 1960s onwards, No. 59 Church Street began its transformation into Davenham Players Theatre.

All sorts of costly adaptations were needed in order to create the small theatre. Buying the property itself entailed some complex negotiations with the Church Commissioner owners, and a stage and an auditorium also needed to be constructed. Innovative fundraising schemes proved to be successful, however, and the Davenham Players Theatre was officially opened in 1975. Since then, the small seventy-seat theatre has developed in many different ways. It hosts touring theatre company productions and jazz events, and some of its leading lights performed very creditably indeed when answering questions on BBC2's popular *Eggheads* quiz show (aired in February 2019).

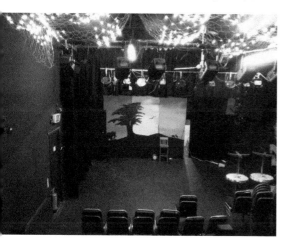

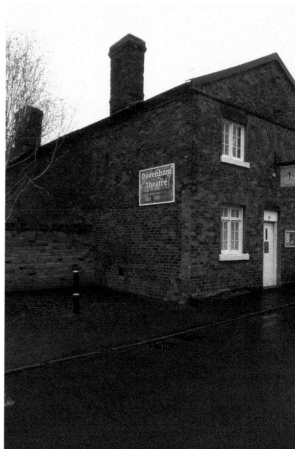

Above: The Players' Theatre stage.

Right: Davenham Players' Theatre.

45. Northwich 'Old' Fire Station

The 'old' Northwich fire station, on Chesterway, was built during the early years of the Second World War. The firefighters based at the station during these wartime years were part of a nationalised organisation – the National Fire Service – which had been formed to meet the challenges of total war. Once the war had ended, the service was deregulated, and the old Northwich Fire Station became part of the Cheshire County Fire Brigade in April 1948.

The Cheshire County Fire Brigade was in turn controlled by Cheshire County Council, which divided the county's fire service into four districts. The fire station on Chesterway became part of 'C' district. The fire station continued to operate until 1973, when it was replaced by a new station operating from Braddon Close, just off London Road, in Leftwich. Ten houses were also built nearby, to accommodate whole-time firefighters who worked at the station during the day, but could also respond to calls at night.

This 'new' fire station has now been in operation for well over forty years, and is now adjudged to be in need of some modernisation. As a consequence, the Leftwich station is one of twenty-one Cheshire fire stations targeted for an upgrade in the next few years, as part of a 2018 Cheshire Fire Authority improvement package worth in excess of £8,500,000.

The 'old' Northwich fire station.

46. Roberts' Bakery

The substantial Roberts' Bakery building, at Rudheath, has been a familiar sight to drivers on the A556 Northwich by-pass road for many decades. The bakery is a family-run business, managed by successive generations of the Roberts family, which can trace its origins way back to 1887, when Robert Roberts opened a grocer's shop at No. 1 Wellington Street, Castle, which ironically (given Roberts' future career path) sold flour but not bread. By 1894, the Roberts family's future was definitely bread centred, and a new substantial bakery was opened in Station Road, Northwich, where the business stayed for the next fifty years.

In 1937, the Roberts brand expanded to include the former Middleton's bakery, on Warrington Road, and in 1952, the ever-developing Roberts business moved to its current location in Rudheath, just at the entrance to what is now the substantial Gadbrook Park industrial estate. The new bakery in Rudheath, called the Red Rose Bakery, was built on a greenfield site, in an environment very different to today's bustling Gadbrook Park estate. From the very start, in 1952, the Rudheath bakery was a major production facility, employing twelve bakers who produced 600 loaves of bread an hour. By 1962, the Roberts bakery was producing 90,000 loaves a week, and by 1967, over 200 people were employed at the facility, and a fleet of fifty vehicles carried Roberts' bread all over the country.

Expansion of the Roberts Bakery building at Rudheath has continued into more recent times. Undoubtedly, the most iconic parts of the building are those which house the huge transparent glass cooling towers at the front of the bakery (built in 2000) where passers-by can view thousands of loaves moving around conveyor belts during the automated production process.

Below left: The two glass-fronted Roberts' Bakery cooling towers.

Below right: Conveyor belt bread exiting the cooling towers.

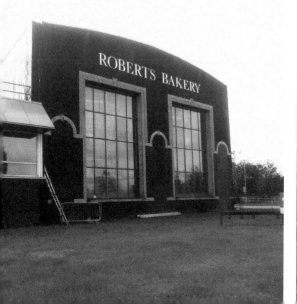

47. Kingsmead Primary School

Northwich has a long history of innovation in architecture and building. Its composite portable structures of the early twentieth century were a precise and 'cutting-edge' response to the problems caused by subsidence and the salt industry. Similarly, at the beginning of the twenty-first century, Kingsmead Primary School (situated at the heart of the new Kingsmead housing estate) was an innovative attempt at creating a public building, using green technologies, which helped preserve the natural environment. The school, designed by a team of Bristol architects and built in 2004, soon achieved national recognition. In 2004, Kingsmead Primary School was one of five structures across the UK shortlisted for the Prime Minister's Better Public Buildings Award. The following year, the school building won the British Construction Industry's Small Building Project Award, and its Best Practice Award.

 Kingsmead Primary School became a model for environmental school design, which was read about, and followed, across the UK. What were the features of the new school building that made it so environmentally innovative? One key feature was the school's inverted roofing, which allowed rainwater to be captured and then recycled for flushing toilets in the building. In addition, solar panels were installed for heating and electricity purposes, along with thermal insulation of walls and roofing. A biomass boiler, which burns waste woodchips, also ensures that, over time, the energy consumption in the school is between 40 and 60 per cent less than in more conventional public buildings. Collectively, it is estimated that these environmental, energy-conscious measures should reduce carbon dioxide emissions from the school by around 5 tons a year.

Kingsmead Primary School at night. (Courtesy of Kingsmead Primary School)

Inverted roof, which assists in the capture of rainwater. (Courtesy of Kingsmead Primary School)

48. Sir John Deane's College

The history of Sir John Deane's College can be traced back to 1557, during the reign of Bloody Mary, when Sir John Deane founded a free grammar school for boys in Witton. Deane was a local boy, born in Shurlach, who forged a successful career in the church, and thrived under both Catholic and Protestant Tudor rulers. He made his money from buying and selling Church lands acquired after Henry VIII's Dissolution of the Monasteries, and at least some of the profits he derived from these activities were ploughed into the establishment of the new school at Witton.

In its earliest days, the school was very closely associated with St Helen's Church, and occupied buildings on the church's land. The school was based in Witton until 1906–07, when the great local industrialist Sir John Brunner agreed to fund the school at a new location (with attached land and facilities) on the banks of the River Weaver. The institution has been at the same location, now in the middle of the extensive Kingsmead estate, ever since. Subsequently, Sir John Deane's (SJD) became part of the state sector, run by Cheshire County Council, but remained a boys' grammar school which also admitted some boarding pupils. By the end of 1978, however, the school had been transformed into a mixed voluntary controlled sixth-form college. Since then, the college has expanded enormously. As a result, new buildings and facilities were clearly required and, in 2010, a major construction programme was launched.

The original Brunner grammar school building became the new college canteen, and seven new teaching blocks were constructed. These new buildings were designed to be environmentally friendly, with a 15 per cent reduction in CO_2 emissions planned at an early design stage. The new buildings incorporated a drop-in IT centre, science laboratories, sports facilities, theatre, dance and recording studios. An internal street, with exposed roof beams, was also a key

Above left: New teaching block at the college.

Above right: Internal street/corridor running the length of one of the new teaching blocks.

Below: The original grammar school building – now the college refectory.

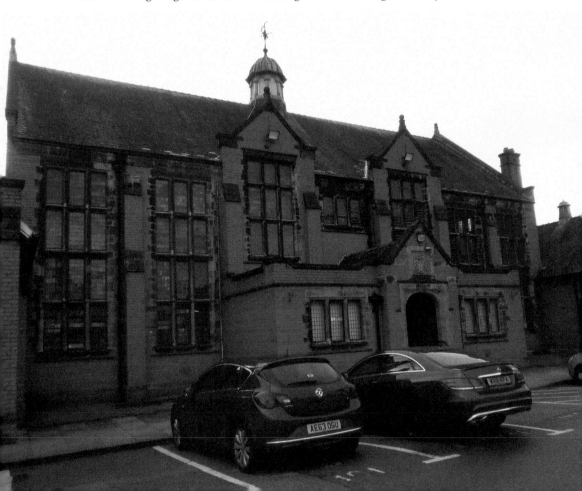

feature of the new main building. The new-look SJD campus was completed in 2011, at a cost of over £22,000,000, and the college remains a considerable success story to this day, with exam pass rates and retention levels ranking it, regularly, amongst the top ten English and Welsh sixth-form colleges.

49. Northwich Memorial Court

Northwich Memorial Court, opened in May 2015, was a replacement for the older Northwich Memorial Hall, which had stood on the same site in central Northwich – between Chesterway and the River Dane – between 1960 and its demolition in 2013. The old Memorial Hall had been a notable concert and functions venue for decades, witnessing performances from world-famous pop groups like the Beatles. The new Memorial Court is also a concert venue, with a state-of-the-art 500-seat auditorium, stage, dressing rooms, bars and kitchen areas. The new Northwich Memorial Court building took approximately sixteen months to construct, at a total cost of £13,700,000. The new public building has many of the eco-friendly credentials required of a twenty-first-century construction. It has solar panels in its roofing, and a 'green roof' with planted sections designed to increase biodiversity and aid drainage. The external appearance of the new Memorial Court has not excited universal approval. Nevertheless, inside, the building's sophisticated dual-purpose design, incorporating both an entertainments and events area, and a sports area, offers visitors some of the very best facilities available anywhere. There are, for example, two swimming pools available. The main pool is a six-lane 25-metre pool, and this is supplemented by a smaller learner pool with a moveable floor. There is also a large eighty-station gym and a dance studio housed within the sports area.

Below left: Brockhurst Street entrance to Northwich Memorial Court.

Below right: Internal street/corridor linking the Brockhurst Street and Chesterway exits.

As with other modern Northwich building projects such as Barons Quay, the preparations undertaken at the Memorial Court site before construction actually began were quite extensive. The construction company undertaking the project had to surmount the challenges presented by what newspaper reports of the time referred to as 'unsteady ground'. This has some obvious historical echoes in central Northwich, where the builders of a hundred years ago certainly had unsteady ground to contend with, in the form of land subsidence caused by the effects of brine extraction. The ground on which the Memorial Court was being built had to withstand the massive weight of the building itself. In addition, it had to support the weight of 500,000 litres of water in the two pools (which take two days to fill). In order to provide the building with solid foundations, piles for the structure were driven 10 metres into the ground. The ground work for the foundations also includes 1.6 metres of stone and 300 mm of concrete, and the foundations for the structure as a whole are knitted together, in ultra-modern fashion, with a geogrid mesh.

50. Barons Quay

Most people in the Northwich area have heard of, and visited, the substantial Barons Quay retail and leisure development right in the heart of the town. It's a 225,000-square-foot development, designed by the architects Broadway Malyan, and completed by contractor Balfour Beatty during 2017. A 28,000-square-foot supermarket quickly became an anchor tenant at the development, along with a new five-screen cinema. Since then, other retail and fashion outlets have opened at the quay. The contemporary, glass-dominated buildings of Barons Quay exist in close proximity to the 'old' Northwich of the black and white timber-framed constructions found on Witton Street. To some, this 'new' Northwich of Barons Quay is unwelcome. To others, it's a refreshing and forward-looking glimpse into the future.

The building of Barons Quay was certainly an expensive undertaking, costing over £54,000,000 by the end of 2016. Preparing the site for the development was in itself an expensive exercise. Some 300 feet below the current retail and leisure complex lay the huge Victorian Barons Quay rock salt mine, where over 500,000 tons of rock salt had been extracted between the 1850s and 1906. This large-scale mining had left over 25 acres of open spaces (or voids) beneath the ground, which all needed to be filled in before building could begin on the surface. The voids under Barons Quay were filled in as part of the Northwich Stabilisation Project, which, at the time, was the largest engineering project of its type anywhere in the world. In total, upwards of 1,000,000 tons of pulverised fuel ash, along with 30 tons of cement, were poured into the voids under central Northwich, in a process which was completed by the end of 2007. Without the successful completion of this groundbreaking subterranean engineering project, the subsequent construction of the Barons Quay retail and leisure development would never have taken place.

Above: View of Barons Quay from Leicester Street.

Below: Barons Quay pedestrianised area, with children's play area to the right.

Bibliography

Barton, F., Day, R., Eastaway, J., *Winnington Manor: A History of Winnington Hall and Winnington Hall Club* (Desktop Publishing, 1998)

Bostock, T., www.thebullsheaddavenham.co.uk Accessed 26/08/19.

British Listed Buildings, https://britishlistedbuildings.co.uk

Clark, D., *The Bridge Inn Northwich*, www.northwichhistory.co.uk/northwich/ 04.05.14.

Crompton, G., *34 Men: A Study of the men of Moulton village who died serving humanity in the Great War 1914-1918*. Neil Plummer, 2015.

Fielding, A. M., Fielding, A. P. (eds.), *Research Report No.2 Salt Works and Salinas*. Lion Salt Works Trust, 2005.

Goulden, J., *Davenham 900+ Years of Work and Worship* (2017)

Hogg, S. (ed.), *Life at Vale Royal Great House 1907-1925. The Memoirs of Mary Hopkirk (nee Dempster)* (Northwich & District Heritage Society, 1998)

Hurley, P., *The Northwich history of famous Victorian Architect John Douglas*. (Northwich Guardian, 29/04/19)

Kingsley, N., *Landed Families of Britain and Ireland*, https://landedfamilies. blogspot.com

Lavell, P., *Historical Notes on the Site of the Former Parr's Banking Company Premises at Danebridge, Northwich*, CRS Consultants Ltd, June 2015

Mid-Cheshire Rail Users Association, www.mcrua.org.uk/sstation/northwich/

Northwich Guardian, *The trials and tribulations of building Northwich Memorial Court*, 29/04/14

Northwich Guardian, *The 15-year battle to open the Greenbank Hotel in 1894*, 12/10/17

UCL Summary of Individual legacies of British Slave Ownership, https://www.ucl. ac.uk

Acknowledgements

The authors would like to express their gratitude to the following people, for their help and advice, and for allowing access (for the purpose of photography) to an amazing range of properties: Achilles Asteriades at The Brockhurst, Gina Cottam at Weaver Hall Museum, Erian Ensor at Nunsmere Hall, Robert Godfrey at the Plaza, Joanne Hislop at Davenham Primary School, Nick Hughes and John Berry at Winnington Recreation Club, Revd Robert Iveson at St Wilfrid's Church, the Law-Lyons family at Whitehall, Richard Leigh at Belmont Hall, Peter Lowery at Sandiway Golf Club, Revd Jane Millichip at St Helen's Church, Katie Murray at Sir John Deane's College, Chris Mundy at The Salty Dog, Ian Proudman at the Greenbank Hotel, Fr Paul Standish at St Wilfrid's RC Church, Witton, Clive Steggel and Heather Kearns at CRS Consultants, Catriona Stewart at Kingsmead Primary School, Linda Stockton at Winnington Hall, United Utilities. Thanks also to staff at the Bull's Head Inn, Davenham Players Theatre, Hartford Hall, Northwich Library, Roberts' Bakery, Vale Royal Abbey Golf Club, and Willow Green, Davenham. Every effort has been made to fulfil requirements with regard to reproducing copyright material. The authors and publisher will be glad to rectify any omissions at the earliest opportunity.

About the Authors

Adrian Bridge was born a few miles to the north of Northwich, in Bucklow Hill, and has taught history in various FE and HE institutions across the country since the 1980s. Since retiring as a senior history lecturer, Adrian has written extensively on both educational and historical issues, and continues to work as a senior assessment specialist in Tudor and Stuart history for the Cambridge Assessment wing of the University of Cambridge. Adrian's wife, Dawn, originally from Stoke, moved to Northwich after completing a history degree, and is a specialist in women's history and genealogical research. She has produced and delivered exhibitions on *Hidden Women of Cheshire*, and has made significant written contributions to the online *Amazing Women by Rail* project.

Also by the same authors

A–Z of Northwich & Around: People, Places, History (Amberley Publishing, 2019)

Forthcoming

Chester's Military Heritage (Amberley Publishing)